# Umoja

# Umoja

Compiled and edited by
Marcellus Nealy
Biankah Bailey

Layout and cover design by
Marcellus Nealy

Front cover photo by
Augustus Browning II

Back cover photo by
Marcellus Nealy

Editorial Staff

editor-in-chief: Jordan Smith
editors: Jeffrey Johnson, Barbara Summerhawk, Mat Chiappe,
and Grace Jickling

copy editor: Joy Waller

Published in Tokyo, Japan
Tokyo Poetry Journal

# Table of Contents

Umoja is the Swahili word for unity. It seemed a fitting title to describe the spirit of this collection of works. Our unity is woven from the many visions of the black diaspora. If you listen, you can hear our stories in almost every corner of the planet, from the lush hills and emerald waters of Jamaica to the neon-colored cities of Japan. You can hear it in the tales of America's streets and in songs of African savannas. Out of the many modes of self-expression comes the unified voice of the black diaspora.

This offering is an attempt to showcase a diversity of talent not just across the cultures that make up the black diaspora but across different media, styles, and points of view. In celebrating the diversity of our cultures and creative styles, we strengthen the force of our umoja.

We are many and we are one.

# Marcellus Nealy

Although he has been writing poetry since he was eight years old, Marcellus found his poetic voice in the mid-1990s on a small stage in Tokyo, at the popular British pub, What the Dickens. From there, he dove full-on into the world of spoken word. He is the winner of several international poetry slams. He has been invited to perform globally at well known events like the Montreal Jazz Festival, Heineken Greenroom Festival in Singapore, and the globally televised charity event Live 8, which over 1 billion people viewed. He also made several appearances on the highest-rated Japanese television show, Kohaku Uta Gassen, with Japan's most legendary pop band, DREAMS COME TRUE. He spent an eight-year residency with the band as a lyricist, rapper, spoken word performer, and background vocalist. He is also an accomplished photographer who has won several awards, including a top prize in Ron Howard's "Imagine8" global photo contest, sponsored by Canon.

Currently, Marcellus works as a narrator and announcer for NHK, and holds the position of associate professor of English at a prestigious university in Tokyo.

# i am

i am the boat that rocked
when the cargo was jettisoned
after horizons were gone
and the traders could no longer be seen
silhouetted against the burning village
counting dutch and english gold

i am the foot that stomped
in the mud of plantations
where blistering death consumed the drum
where words were cut from their tongues
and stitched back in with unsterilized needles
a new language

i am the welt that burned in hot summer suns
on the palms, soles, hands, feats, backs of the beast
worth one third a whole man
but maker of a nation, of economic boom
of textiles, and tobacco

i am the vessel of a new god
sent from the sons of abraham
across the nile
to coliseums where lions feasted on flesh
took constantine's degree
then passed it on
to king james, gutenberg, and the klan
till the rivers no longer flowed
the winds no longer blew
and the rains no longer gave meaning to her tears

i am the zoot-suited minstrel
ducking into speak-easys anything but silent
my bass beats scream release from the metal made magnificent
with the wood and string of the times

i am the line that stood shuffling

head low yessir boss
from the back of a packed house
full of spirits that would eventually posses them
even those who sipped sweet water
and wasted into exquisite porcelain
while the makers of their mood
and the bringers of their food
sifted grit from their teeth and swatted flies
from the crusty covered seats

i am the uprising
the realization,
the hundred years after emancipation
the deacons who defended,
the panthers who growled
against the gnashing fangs of hell hounds
let loose on liquefied streets
amid the voices lifting themselves to sing

i am the bulleted King,
Parks in prison,
those plucked by the wing that Holiday wailed of
the unsolvable equation
the elimination of X
i am the wave of new consciousness
uncovered freedom
the fuel for Scott-Heron's untelevised revolution
the last of the poets unafraid to speak
the rage the swell the raucous coalition
that found fruition
despite the ghetto lands

i am the bang up western of Tookie
the clash of california
the red and blue that brought fear
to the white brown yellow black
populations that withdrew into deeper denial
as the outlaws flung rocks at business men and suburbanites
who risked their lives for the high.

i am the subject of experimentation
that lingers long after tuskegee
somewhere in harlem, cleveland, or watts
where truckloads of brown bricks
smack silliness into the federally funded nod of intoxication

i am the yearning burning within the crossroads of Johnson's howl
the bitches brew,
bubbling stew that moved from reefer madness
bane of society,
white daughters salivating
to every society
from alabama to aoyama
changing form
bebop, blues, rock to german b-boys of bad nauheim
who are without knowing
what it is to really be

i am the culmination of things unmentioned but known
the traffic light, the safety pin, the gas mask, the cure for cataracts
the paper punch, the electronic resistor, the dry clean, the solar eclipse,
the peanut

i am the forgotten names
called buffalo by indigenous people
pushed forward to the oil fields
i am the artist the inventor the visionary
the entertainer the athlete
the past present future bringer of world culture
the gangster the drug dealer the father
the astronaut the statesman the wise man
and sometimes the fool

i am the living proof
that despite all the katrinas ignored

i will find a way to survive

## the sky melts to become the sea
## (in other words, the end)

over the grassy knoll
the horsemen road across my mind
sixteen upon the turf bent blades
of fresh summer promises broken
the rumble of sound being belched
from the core of creation

there is no man or whole nation
that could listen and understand
or watch when the dolphins began
to walk on land
shedding the salt
shedding the sand
as the yard birds flew
migrating south en masse
a massive movement
mass exodus

the farmer
with a hatchet over his head
screams come back come back
as the crops begin to congregate in the fields
plotting a photosynthetic coup d'état
the animals pass a chillum around
and use it to transform their grunts and squawks
into comprehensive speech patterns
into a true language they use
to communicate with their gods

i rise with the visions they exhale
and sail on sunbeams as they set me free
i watch most curiously
as that thing careens to us
from outer space
how the sky melts
and becomes the sea

## tokyo commuter train

muffled and nasal
the announcer tells them where they are
and how far they have to go

slide... and old ladies move explosive
out of their station starting blocks
into empty spaces
elbows and shoulders in offensive fashion
appearing weak before youth
who pretend to be asleep

the loud and long whistle
of the train man
the morning pace setter
snakes up stairs
and out the sides of station buildings

slide... and the match is on again
silver seats full
the frail and world-weary
wiggle and push their way
to guilt giving stances
till the sitting are no longer able to look away
head sway when the smooth line of the rail bends
and strange shoulders make magnificent pillows
wicked hands move through the tubed light
young girls dying a circular death
cornered lovers laugh and hold what matters of the moment
while crimson faces strain and flop
struggling with the serpentine dragon-like motion
always ending up in worship position
poised on the edge
of some great
eruption

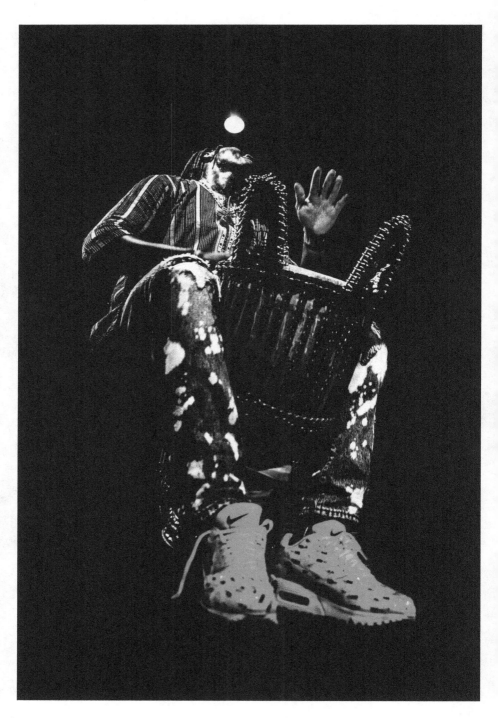

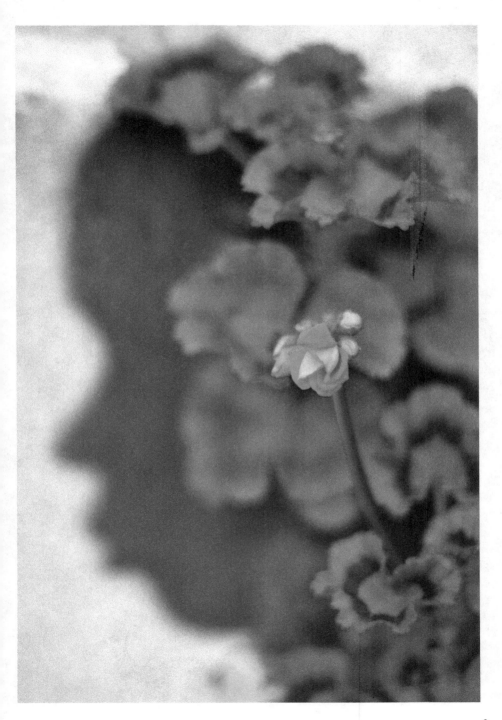

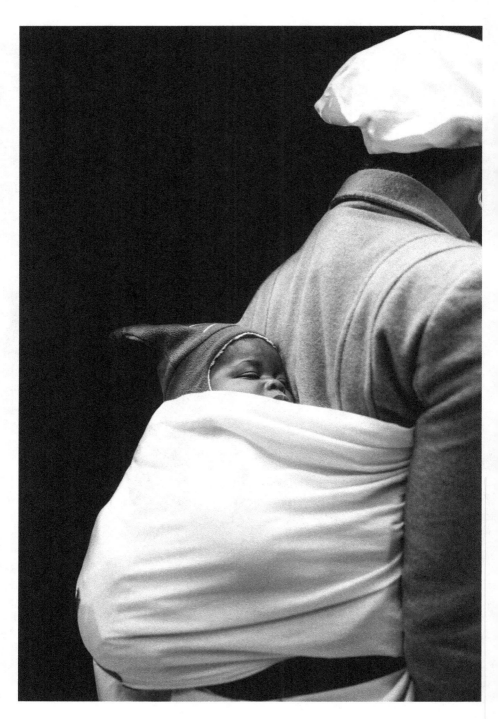

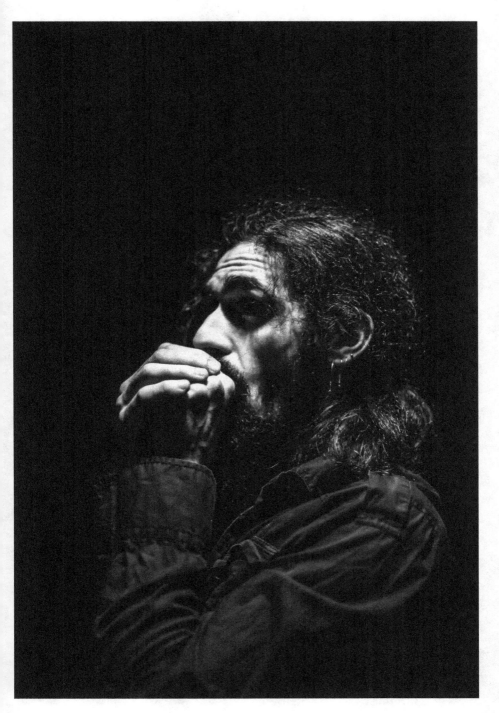

# Christopher Deborah

Christopher Deborah Iniobong is a twenty-year-old Nigerian who is currently studying at the University of Benin, Nigeria. Professed to be weird by many, she spends her free time writing, drawing and thinking. To her, poetry is art and it should reveal the thoughts of its master however different it may seem, for in its varied shape and size, true beauty is seen.

## Drums
You echoes of a thousand voices
Trapped within the thick buffalo skin
Covering the hollow chamber
Of a wooden mortar
Reign over the air in a mystic dance
Let your notes pulsate thus
"Ganmu ganmu do do"
A tear escapes the clear window
Of veiled emotions and longing
To land on the web of history
History to gouge eyes unblinking
Clumsy fingers rising and sinking
In guided speeds of recklessness
On defeated drums embracing time
Rejoice no more as the enemy is in the camp
Waist beads of maidens swiftly expand
And drop down their luscious hips
To break into a million pieces scattered about

## Chants
You murmurings of a disguised oracle
Take hold of silence and tear it into pieces
Look yonder! See the sad procession
Shackled drummers, singers and dancers
Swaying weakly to the music from rattling chains
Where heavy metal adorns long necks
And clamp tightly around feeble wrists
Look ahead! See the moving train!
The rail roads be the fallen vessels
Bodies who give in to preying miseries
Wheels be the many chained dusty feet
Pierced by the shattered waist beads
Blood open wide the door of cracked skins
And flow freely on rocky paths to be covered in dust

For footprints soon disappear
Legacies buried with the howls of the pained procession
Whose voices are trapped by the white mist

## Rituals

In your name do foreign tongues wag
Your beauty be dipped into the paint of assumptions
Evil! Barbaric! Sorcery!
The calabash which we drunk from without care
Be cracked open when dawn struggles against the dark
Priests adorned in red and black!
You who draw with the chalk a circle
'To communicate with the dead' You said
Shuddering like he had been overtaken by a million spirits
Eye of the gods blinded by the faithless generations
Throw the confused world into more chaos
As you hit earth repeatedly with the iron staff
'Abomination' Your eyes turn to the heavens
Let the dust raised plead with the gods
As will the convulsing bells ringing from the staff
Shield and spears buried along side gallant warriors
Never to be wielded in honour of the right
Death where life springs in massive trees
And roots ignored and scorned

## Cockerel

You who laid the foundations of the earth
Spreading sand in a world defined by still waters
Brown skinned figures rise from the mud
Blessed by the sun to withstand pain
Bearing with them the heart of brotherhood
Cockerel, who bound your feet so?
Who put out the light of wisdom beneath the moonlight?
You hop awkwardly in every direction!
Your ceaseless clamour for freedom
While you beat your wings wildly
Your wings have they been clipped!
Your feathers lie piteously on thorny grounds
Grief wrenches from your core, life's kisses
Death took hold of you and ferried you to the gods' isle

## Mama Africa

Fifty-four times did you scream in anguish
Did the universe curse you too during childbirth?
That pain be the pincers of many crabs snapping
While you push amid all that suffering
Oh motherhood! That your children forget you
And be scattered abroad like stars on high
Mama, your jewels are scattered on fertile grounds
But poverty hold your offspring by their collars
Many times did you weep in agony
Your generations are faraway in a vast land
Mama, how then can your name be revived?
They are tracing their roots
And every road leads back to you
Mama, in lush greens whisper your name
That your honour be restored again
And your children wear the apparel of unity
And chant the ancient song of warriors
The sound of the raging wind

# Anthony Joseph

Anthony Joseph is an award winning Trinidad-born poet, novelist, academic and musician. He is the author of four poetry collections and three novels. His 2018 novel Kitch: A Fictional Biography of a Calypso Icon was shortlisted for the Republic of Consciousness Prize, the Royal Society of Literature's Encore Award, and long listed for the OCM Bocas Prize for Caribbean Literature. His most recent publication is the experimental novel The Frequency of Magic. In 2019, he was awarded a Jerwood Compton Poetry Fellowship. In 2020 a Polish translation of his afrofuturist classic The African Origins of UFOs was published, followed by a Spanish edition of Kitch. As a musician, he has released seven critically acclaimed albums, and in 2020 received a Paul Hamblyn Foundation Composers Award. He is a Senior Lecturer in Creative Writing at De Montfort University, Leicester.

## Conductors of His Mystery
for Albert Joseph

The day my father came back from the sea
broke and handsome
I saw him walking across the savannah
and knew at once   it was him.
His soulful stride, the grace of his hat,
the serifs of his name
~ fluttering ~
in my mouth.
In his bachelor's room in El Socorro that year
he played his 8-tracks through a sawed-off speaker box.
The coil would rattle and the cone would hop
but women from the coconut groves
still came to hear
his traveller's tales.
Shop he say he build by Goose Lane junction.
But it rough from fabricated timber string.
Picka foot jook wood
like what Datsun ship in.
And in this snackette he sold   red mango,
mints and tamarind.
Its wire mesh grill hid his suffer well tough.
Till the shop bust,
and he knock out the boards
and roam east
to Enterprise village.
Shack he say he build same cross-cut lumber.
Wood he say he stitch same carap bush.
Roof he say he throw same galvanize. He got
ambitious with wood
in his middle ages.
That night I spent there,
with the cicadas in that clear village sky,
even though each room was still unfinished
and each sadness hid. I was with
my father
and I would've stayed

if he had asked.
Brown suede,
8 eye high
desert boots.   Beige
gabardine bells with the 2 inch folds.
He was myth.   The legend of him.
Once I touched the nape of his boot
to see if my father was real.
Beyond the brown edges of photographs
and the songs we sang
to sing him back
from the sweep and sea agonies
of his distance.
Landslide scars. He sent no letters.
His small hands were for the fine work of his carpentry.
His fingers to trace the pitch pine's grain.
And the raised rivers of his veins,
the thick rings of his charisma,
the scars — the maps of his palms —
were the sweet conductors of his mystery.
Aiyé Olokun.
He came back smelling of the sea.

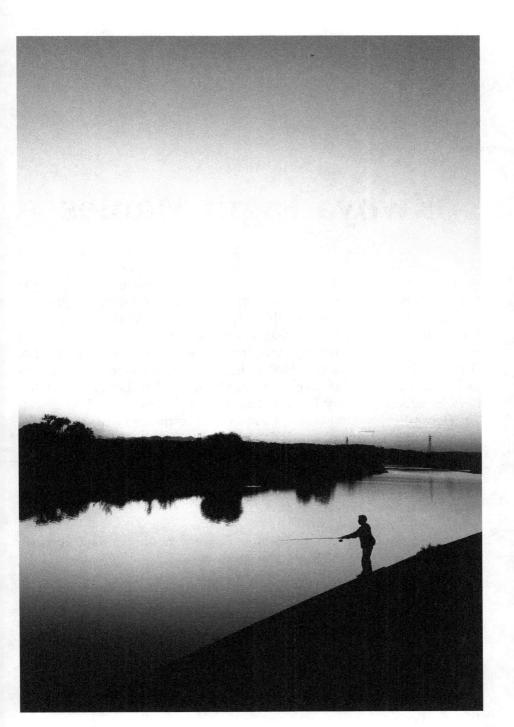

# Kwoya Fagin Maples

Kwoya Fagin Maples is a writer from Charleston, S.C. She holds an MFA in Creative Writing from the University of Alabama and is a graduate Cave Canem Fellow. Maples is a current Alabama State Council on the Arts Literary Fellow. She is the author of Mend (University Press of Kentucky, 2018) a finalist for the 2019 Hurston/Wright Legacy Award for Poetry and finalist for the 2019 Housatonic Poetry Award. In addition to a chapbook publication by Finishing Line Press entitled Something of Yours (2010) her work is published in several journals and anthologies including Blackbird Literary Journal, Obsidian, The Langston Hughes Review, Berkeley Poetry Review, The African-American Review, Pluck!, Tin House Review Online and Cave Canem Anthology XIII. Mend tells the story of the birth of obstetrics and gynecology in America and the role black enslaved women played in that process. This work received a grant from the Rockefeller Brothers Foundation. Prior to publication, Mend was also the 2017 finalist for the Association of Writers and Writing Programs' Donald Hall Prize for Poetry.

Maples teaches in the MFA program in Creative Writing at the University of Alabama, home of the Black Warrior Review.

## Elegy for a Stillborn
From Mend

"All of my children have died or wandered away." – Molly Ammonds, Alabama Slave Narratives

Here are the milk and songs
from my breast. Here is his cover
sewed from calico scrap and dyed
with peachtree.
Take it for nights when he is cold.
Here is the sheet I washed
in secret, to catch him
when he came. It was to give him
a clean start.
Take the old dresser drawer
I used for a cradle.

You will need pins
from the washwoman and this wrap from my hips—
You can carry him
against your back.
Take the knife
from under my bed
that they used to cut the pain.

I did not make a basket of medicine
I did not want to mark him sick,
But here is pine-top tea, and elderbrush
Here are mullen leaves for when he cuts teeth.
Here is his corn husk doll,
same as all the rest. And take
the place I prepared for him
near the fire,
the quilt folded in half then again
so he would rest
against something
soft. Take the room full
of times my hand crossed over my belly,
a prayer on my lips.

Maples, Kwoya Fagin. Mend: Poems. © 2018 The University Press of Kentucky. Used by permission.

# LaTasha N. Nevada Diggs

A writer, vocalist, and performance/sound artist, LaTasha N. Nevada Diggs is the author of TwERK (Belladonna, 2013). Diggs has presented and performed at The California Institute of the Arts, El Museo del Barrio, The Museum of Modern Art, and The Walker Art Center and at festivals including Explore the North Festival, Leeuwarden, Netherlands; Hekayeh Festival, Abu Dhabi; International Poetry Festival of Copenhagen; Ocean Space, Venice; International Poetry Festival of Romania; Question of Will, Slovakia; Poesiefestival, Berlin; and the 2015 Venice Biennale. She and writer Greg Tate are the founding editors of Coon Bidness YoYo/SO4 magazine. As an independent curator, artistic director, and producer, Diggs has presented events for BAMCafé, Black Rock Coalition, El Museo del Barrio, Lincoln Center Out of Doors, and the David Rubenstein Atrium. Diggs has received a 2020 C.D. Wright Award for Poetry from the Foundation of Contemporary Art, a Whiting Award (2016), and a National Endowment for the Arts Literature Fellowship (2015), as well as grants and fellowships from Cave Canem, Creative Capital, New York Foundation for the Arts, and the U.S.-Japan Friendship Commission, among others. She lives in Harlem and teaches part-time at Brooklyn College and Stetson University. Formerly a resident of Tokyo, she now lives in New York City.

from Thought Sports [1]

## Dejima

para T y P y M

let's play a game: first step? wife or wet nurse?
heathered fragrance of breast milk or perfume?
whose ginger curlicue crushed shōguns. whom
is worth study? umeboshi kyōi. pursed
cheeks, flushed freckled, unsought laws crashed verse
nutmeg. cooper. flecked hint of Marathy.
mamushi christened for baby daddy
exchanged facades on a fan shaped island
oddities. neither skilled courtesan almonds
who receives clover, astrolabes, lacquer, cohi.
drops of bonyū sweet rice spectacled aijin[2]
did honor let the boy pick up Nihongo?
a single vase might have stored cane azijin[3]
cherries for the daughter. what for the Jawa-go?

before bombing Nagasaki

a Akage mardigras[4]
um ryôtei[5]

where geisha charged triple for Dutch

---

1 Thought Sports is a series of multilingual poems written during a two-week residency in
Leeuwarden, Netherlands in 2019. These poems explore not only language but also the cross-sections
of the Dutch engagement with other cultures via trade, colonial rule and assimilation through the
eyes of a Black/Indigenous female body.
2 Japanese, mistress
3 Japanese, vinegar
4 Japanese, red hair
5 A type of luxurious traditional Japanese restaurant. Traditionally they only accept new customers
by referral and feature entertainment by geisha, but in modern times this is not always the case.
Ryōtei are typically a place where high- level business or political meetings can take place discreetly.
(Wikipedia)

## Oompa Loompa

soy aquí new tongue. can you welcome this
gaze towards words unspoken by a cynical generation? dump
some luster of rulers. your labor deserves plaudits. of
pompeblêd never explained. just expected. yours
a root I may retain just the slurs. general blah blah is null. so
simply: we are bipedal but we be natural idiots. plainly, full
of ourselves; driven to control the oceans, the winds, adjectives. your
cheese is mean, friend. like pungent crunch. but we knew this. skin
fished & fry up. I thought it was the French to blame on mayo. a
deaf waitress serves/teaches me 'espresso.' a cashier denies me stamps.
                              coat
the roofs w/ hert e ja e taal e mem. no volume raised though. so
who hears if unable to read? does this hand need be this heavy?

elaborate for me this thing about Frisian women. evidence of heavy
unfettered traits all leading to Famke Janssen. bad example? so…
ferhoalen ferhalen. the Dutch 'g' estou não meu compadre. relatives not.
                              coat
of honey on Spain o Arawak o (insert African/Asian root here) well,
                                             then we duet. a
transfer of particles across ponds where escaped, we collage. my skin
code switch; longing tropics, it pales beside Waddenzee. your
oak thrives in sand as I digress to YouTube tutorials to catch di riddim.
                              full
of joy. alas the shop for Clumpys is open from 12-5. the tallest in Europe
                              eh? so
what about the Danes? hung like Grutte Pier? get yours
vertical ascents. damn your staircases. scalene, obtuse triangles of
of hell. misdirected retribution for fiending Vlisco. dump
more tea inna dey cup please. até mais moanna. my lessons are this.

## Agehya – Zumbi

after Stanley Brouwn

o número total de minhas passos em          The Bronx
the total number of my steps in

watashi no suteppu no sōsū                   Harlem
the total number of my steps in

el número total de mis pasos en              Helmond
the total number of my steps in

watashi no suteppu no sōsū                   Nishi Ogikubo
the total number of my steps in

o número total de minhas passos em           North Carolina
the total number of my steps in

watashi no suteppu no sōsū                   Okinawa
the total number of my steps in

el número total de mis pasos en              São Salvador de Bahia
the total number of my steps in

watashi no suteppu no sōsū                   Taxco
the total number of my steps in

o número total de minhas passos em           Tsalagi
the total number of my steps con

watashi no suteppu no sōsū                   Waddenzee
the total number of my steps in

el número total de mis trapus en             Ilè Yorùbá

# Michael Harris

Michael Harris (aka exhipster) is an American based in Tokyo who spends his evenings after work and weekends wandering the streets of Tokyo looking to make interesting photos.

In July 2021, the influential Asahi Shimbun Photo Archive officially announced him the Grand Prize winner in the "Change" category for their 2nd Asahi Shimbun Photo Archive Black and White Photo Contest. The photo will be archived as a historical photo and exhibited during future Asahi Shimbun Photo Archive organized exhibitions.

He's inspired by pioneering street photographers such as Henri Cartier-Bresson, Robert Frank, William Klein, Bruce Davidson, Mary Ellen Mark, Elliott Erwitt, Daido Moriyama, and more recent photographers such Boogie, Alan Schaller, and Jeff Mermelstein, along with Japan-based Marcellus Nealy, Joel Pulliam, Juan Carlos Pinto, and Katsumi Nishizawa.

In his photography, his strength lies in the ability to litter throughout the frame subtle details that create eye-catching, and gritty black and white Tokyo street photos.

When not wandering the streets, he's organizing exhibitions for fellow creatives in Tokyo to help give them a voice in the city and around the world.

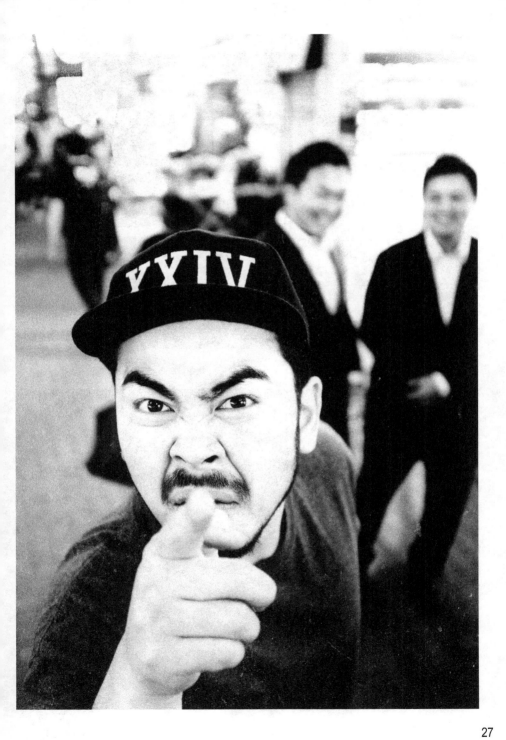

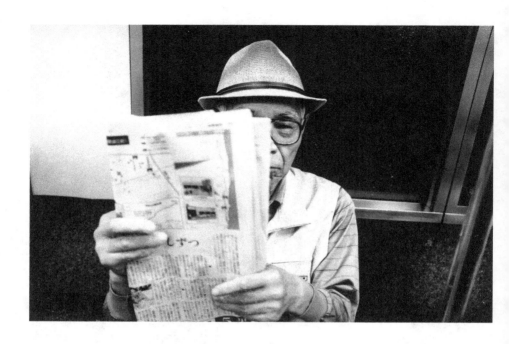

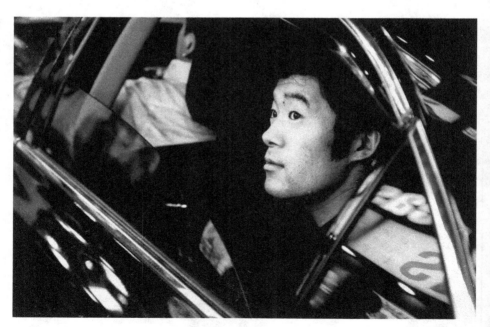

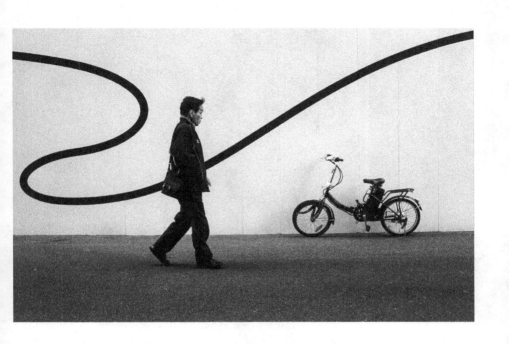

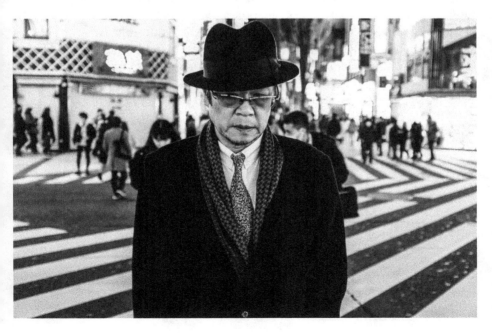

# Nyah Hardmon

Nyah Hardmon is a writing fellow with the Washington Independent Review of Books as well as a spoken word poet recognized by the National Young Arts Foundation and a US Presidential Scholar in the Arts. She is also a Howard University's distinguished 2021 White House Correspondents' Association (WHCA) scholarship winner.

## cocoon

My nana be born caterpillar, but she didn't stay that way.
How silly it is to live a beginning so different from the end.
Scrunched up on ground,
not knowing you will soon be cousins with the sky.
My nana be pretty wings and all.
Fluttering on by one stroke at a time. She be
Free. Tempting the fate of gravity.
Flying high, flying neat.
She laughs and music is born, wings beating to the beat.
When she come around the air grows sweet with rhythm and blues.
She be queen bee and B.B. her king.
Line dancing through the clouds,
my nana be butterflying, in every sense of the word.
Sees the world as her canvas and uses her wings
to paint life onto every surface she kisses,
And man do them wings glisten.
Something straight out of a Maxwell song.
Too pretty to remain on ground so sky is where she be
And man do she be flyin'.
When you've lived how she lived on the other end
You learn to never let go of freedom's hand.
Never forget its taste.
She flies as if the moment she stops she will plummet to ground again.
My nana be caterpillar at heart.
Not knowing why she was gifted such beautiful rebirth
But knowing that it is here now and here it will stay, at least she prays.
My nana be born hopeless
But she didn't stay that way.

# Herbert Kendrick

Q Kendrick is an American artist and professional singer living in Tokyo. His work has been featured at exhibitions in Canada, Japan, and African Art museums in the Washington, DC area. He's currently on tour painting murals in the Tokyo region. From real life to the abstract, Q's art highlights his interests in different cultures, and passion for vibrant colors and positive themes.

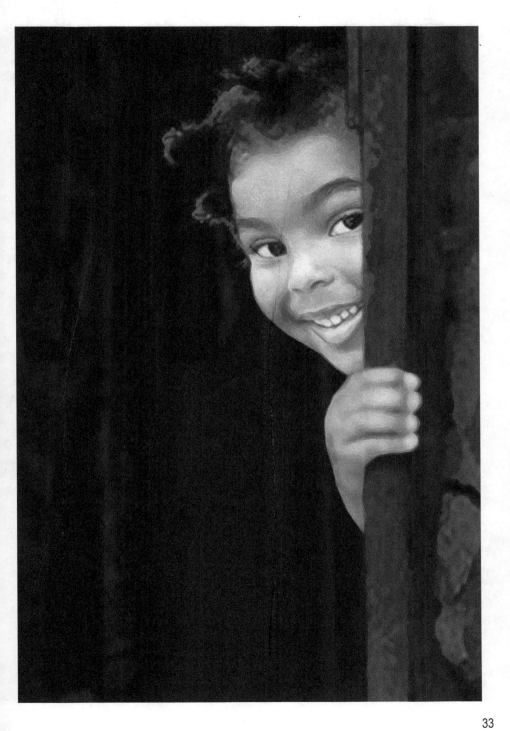

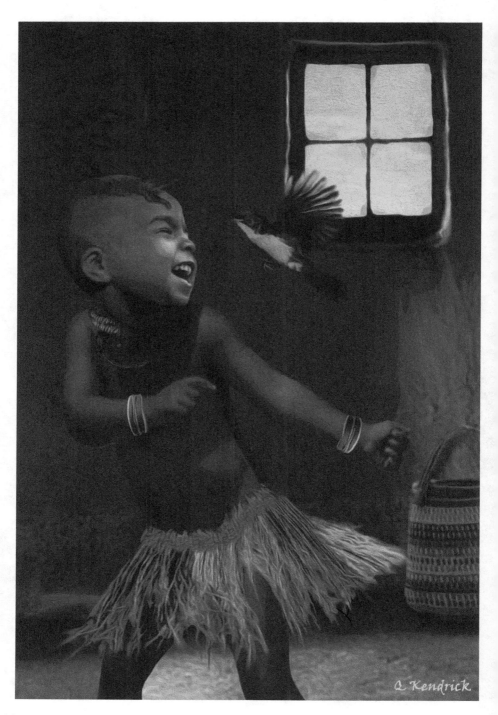

C Kendrick

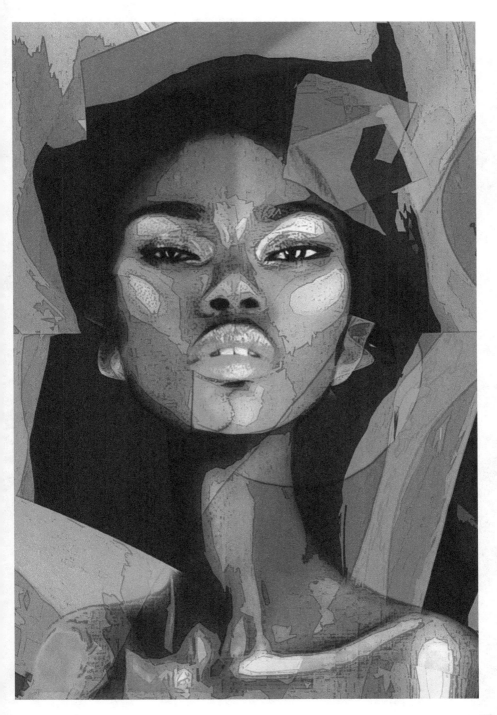

# Addeah Palmer

Addeah Palmer is a Jamaican novelist and poet. To date she has published five books: one with Ian Randle Publishers and the others self-published. These include two novels, two poetry collections, and a book of motivational quotes. Addeah considers herself to be a natural-born writer; in her own words, "It's in my blood." She has been writing as far back as her memory will take her, but got serious about her creative skills in 2015, when she had her first novel, Macca Tree Manns published. She is in the process of completing her third novel, "Water from a Raven's Beak", which is her sixth work. Publication of her poems in the Tokyo Poetry Journal has given her a chance to achieve a dream of reaching a wider audience, outside of Jamaica. She loves her country and believes its rich cultural mix deserves to be showcased.

## The Poetry of my Crosses

My palm lines are not perfect
they are crisscrossed and tell stories of uneven roads
wrong turns and tracks without exits.
With a clap the lines converse
in a hard and fast evolution of spontaneous rhythm.
And when my palms meet in a squeeze
the lines cling to each other so tightly
that they stamp new bruises and create trenches
as deep and vast as the mad ocean.
Then clashing waves of uncertainty
threaten to drown me
and in punishment from the pressure
my lines turn rough and red
from blood coursing through,
giving them new life.
Unable to be rid of my lines or their passion
I unclench and put my palms up in praise.

# Martha Darr

Martha Darr is a poet and essayist with a love of fantasy and oral literature. Some of her recent work has appeared in Typehouse Literary Magazine, Star*Line, Penumbra Literary and Art Journal, and Fiyah: Black Speculative Fiction. She received funding to study performance, oral tradition, and literature from the National Endowment for the Humanities. Martha lives in Oregon, where she enjoys a regular dose of creative inspiration from the natural beauty around her.

## Elements

A sign on the road
Mocked the fatal encounter

Beware of Suicidal Deer

I didn't witness her death
Just sent out a prayer moving
Upwards toward a mountain then i

Dodged poison oak
Greeted meadowfoam
Stared into ponds
Watched birds dance and i

Caressed beneath
A deep rich soil

Bliss renewal at dawn

# Andre Le Mont Wilson

Andre Le Mont Wilson grew up as a Black queer poet and writer in Los Angeles. His poems have appeared in such publications as Failed Haiku: A Journal of English Senryu, Haiku Anthology: Observations and Insights, and Plum Tree Tavern. He has been nominated for a Pushcart Prize. He teaches storytelling, haiku, and writing to adults with disabilities in Oakland.

# In My Backyard

One summer eve, I lay in my backyard
in a bedsheet tent I made in my backyard.

Goose feather pillow, bag of Doritos,
I encamped unafraid in my backyard.

Sleeping bag for bed, a plum for dessert,
I played a renegade in my backyard.

One by one, the lights of my house winked out.
Shadows engulfed the shade in my backyard.

The curtains pulled back. A figure peered out.
Mom prayed I hadn't stayed in my backyard.

The curtains fell back, and she disappeared.
Had I been betrayed in my backyard?

I munched on chips and gazed at the night sky.
The stars blazed when surveyed in my backyard.

Black beetles crawled the packed earth around me.
My finger flicked their raid in my backyard.

Grains of sand itched under my clothes and skin.
My old sandbox decayed in my backyard.

Dad had built it for me before he left.
He and I never played in my backyard.

Sometimes 'Dre feels like that boy in a tent.
Lonesomeness didn't fade in my backyard.

## Hot Dogs, French Fries, Lemonade

Our red stools stood on stars
as we ate hot dogs with
Fats Domino and the Go-Go's
along Hollywood Boulevard.

Lesser known than crosstown rival, Pink's,
Skooby's boasts:
FRESH LEMONADE—THE BEST IN CALIFORNIA.

It is here,
my brother, my sister, my partner, and I
dined on
hot dogs, French fries, lemonade,

and memories of a backyard lemon tree
which fed us meringue pies
and chiffon cakes
baked by our mother
who called herself "Yeller Gal."

Nothing tastes as sweet
as memories relished again—
or as bitter.

We ate our fries
one at    a    time
to pro-looong the moment,
and we nibbled our red hot dogs
as red tour buses passed.
Ice cubes mmmelt.

Snapshot.

I imprint this memory on my mind,
like footprints
at Grauman's Chinese Theatre.

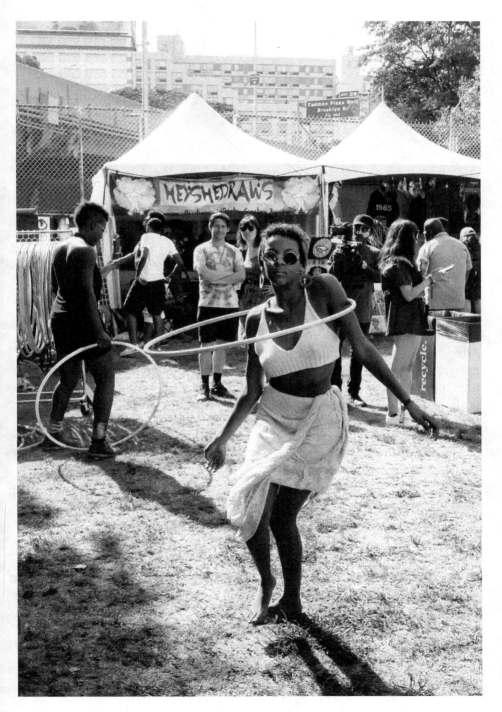

# Alisha Gaillard

Alisha Gaillard is an illustrator who majored in Illustration and minored in Graphic Design at Moore College of Art and Design in Philadelphia, PA. She specializes in digital and Prismacolor mediums on tone paper along with printmaking, and absolutely loves creating works of art that are stylized portraits, overly detailed, or depict the effects of mental health.

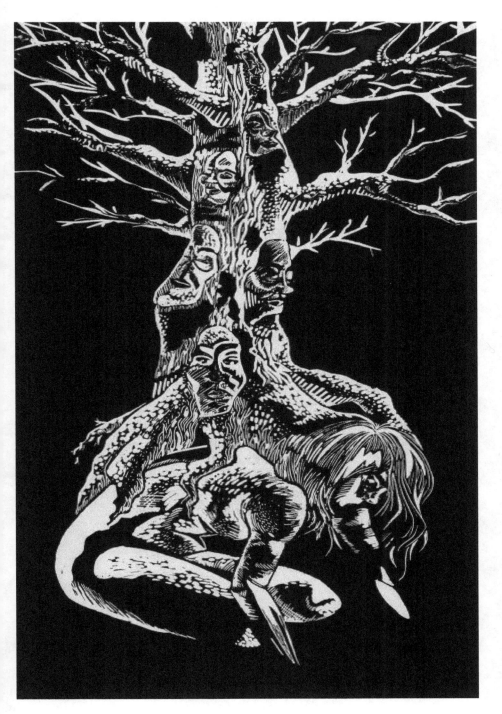

45

# Cassandra IsFree

Cassandra IsFree is a 3x published author, spoken word artist, slam poet, playwright, and award-winning actress from Norfolk, VA. She is a founding member of the Verb Benders Slam Team from Hampton Roads, VA, currently ranked eighth in the nation. She is a 2x Write About Now Slam Poetry Champion, 2x Word is Write Slam Poetry Champion, and a 2x Puro Slam Poetry Champion. Cassandra has been published in Bareknuckle Poetry Journal (Australia) and Defunkt Magazine. She recently won the Editor's Choice Award for the DiBiase Poetry Contest and was selected by Button Poetry during their 2020 video contest to have her video streamed. Cassandra was selected as a winner of the Poetry on the Pavement contest for the City of Norfolk, VA and will have her poems stenciled onto sidewalks throughout the city. She is also an actress and resident poet with TRS Productions and stars in productions throughout the area. Cassandra works as an educator and mentor within the public school system and loves performing & teaching.

## American Haiku: Cycle of a black man
A black boy is born
Father holds him in his arms
Promises the world

Black boy turns seven
Still plays with action Figures
Dad is still hero

Black boy is thirteen
The world says he is a man
He still needs his dad

Black boy now sixteen
Sits at funeral, while dad's
Killer gets paid leave

Black man is twenty
As cop draws gun he follows
His father's footsteps

## American Haiku: Buried Treasure
The mothers' tears stream
And daddies hearts break from weight
Of children's coffins

## Invisible Man
He stands on the same corner everyday
Hand-made sign almost as worn as he is
So now he blends in with the concrete Gray, cemented in his misery
He asks for 50 cents
Never a dollar
50 cents
Says the jingling sound of the coins reminds him of Christmas
And Christmas reminds him of family
Family reminds him that once upon a time, he was not alone
Which makes me wonder, how much are my memories worth?

### Encore

Black pain has always been a source of entertainment
Music to their ears
Moaning and wailing to beautiful ballads of blues
Dancing to the rhythm of ricocheting bullets at our feet
String us up then clap on the down beat
Beat as repetitive as a hung jury when another black gets lynched
They tap shoes to Emmitt's blues
A rhapsody of police brutality
They love our bars more when we're behind them
Our bodies suspended in motion send them swinging
Black boys, b-boys break dance and become running men
Can't quickstep those attempting to tango and tangle
Bodies now swaying to the tune of Strange Fruit
The hook catches them every time
Our Black Swans broken, bent necks as though taking a bow. Encore.

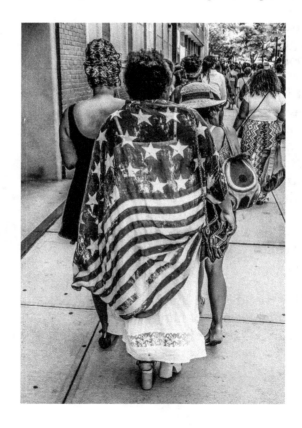

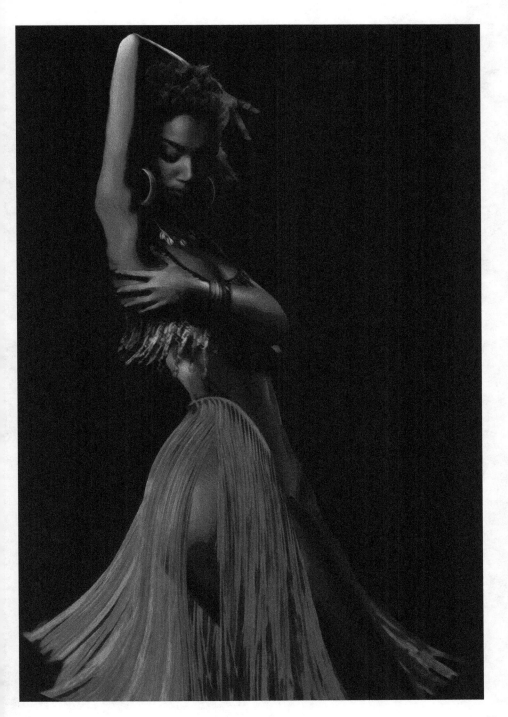

# Johnny Collins

Johnny Collins, also known as Radio The Artist, is an artist and photographer born and raised in Kernersville, NC, USA located outside of Winston-Salem, NC, "The City of the Arts". He has also showcased his artwork in galleries from North Carolina to Tokyo, Japan.

"As a photographer, my work consists of street photography, music bands, and traveling, since my time working in China allowed me the freedom to travel to other parts of Asia for photography work. My interests also include painting, making music, writing, and drawing."

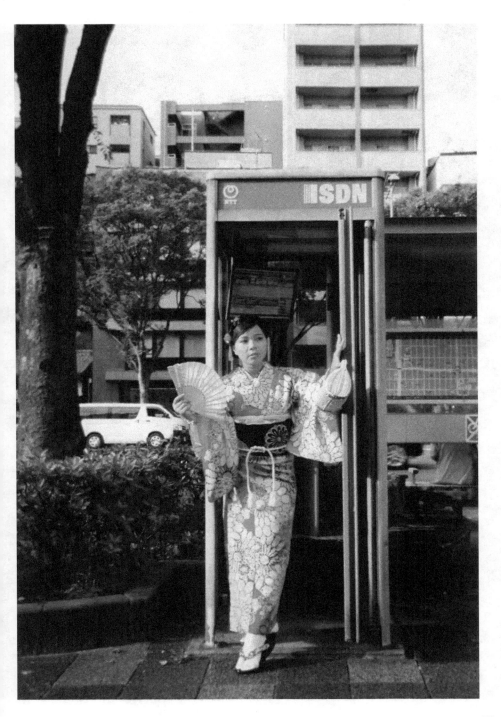

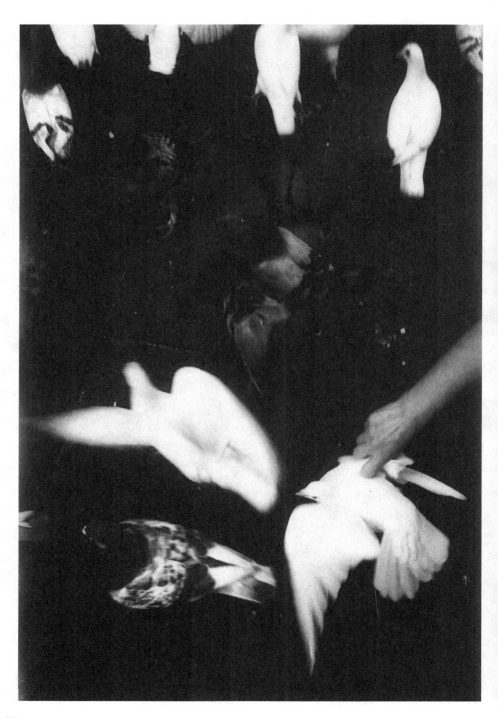

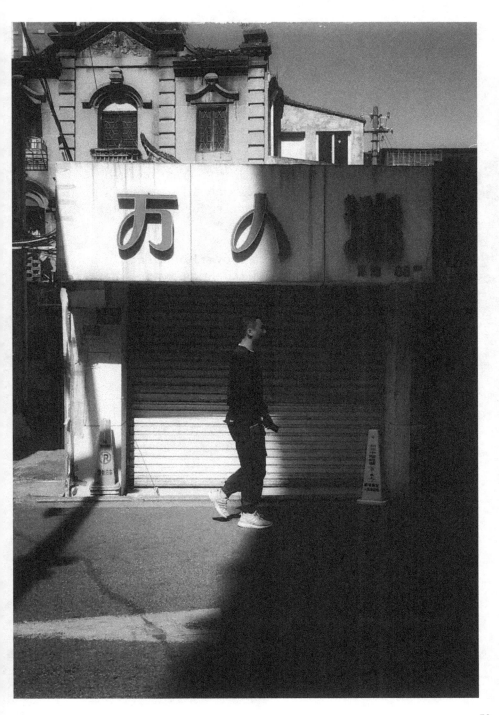

# Darryl Wharton-Rigby

A native of Baltimore, Maryland, Darryl Wharton-Rigby has worked diligently to be a storyteller. He has an MFA in Film Directing from Chapman University and was a Lecturer for Morgan State University's Screenwriting and Animation program.

Darryl wrote for two NBC television shows, Homicide: Life On The Street and Just Deal. His debut feature film Detention received numerous honors and awards. His film Stay makes him the second African-American to make a feature film in Japan. In the world of theatre, his award-winning play FreeDa Slave: Mask of a Diva was mounted in Baltimore and Los Angeles, and his play Here Come The Drums, starring Russell Hornsby, earned eight NAACP Theatre Award nominations.

In Japan, he has worked on productions for Xbox, NHK, Farfetch, Buzzfeed, Airbnb, and Usquaebach Whiskey. As an actor, he is featured as the DJ in the hit AKB48 music video, Koi Suru Fortune Cookie, which has more than 200 million views on YouTube.

Darryl is an international filmmaker who explores the human experience and builds cultural bridges. He is passionate about human and equal rights, LGBTQ issues, immigration, and those who are disenfranchised. Via his work, he'd like to create a level playing field.

Darryl lives in Saitama, Japan and credits his wife and three children as his ultimate muse.

# MYSTERIOUS WAYS: A GOSPEL PLAY
## Darryl Wharton-Rigby

PRODUCTION NOTES

## INTRO, INTERLUDES, & CLOSING

THE CHOIR – MUCH LIKE A GREEK CHORUS, NOT NECESSARILY SINGERS, BUT MORE SPOKEN WORD ARTISTS.

### CAST

ALTO – SINGER/SPOKEN WORD ARTIST
SOPRANO – SINGER/SPOKEN WORD ARTIST
BASS – SINGER/SPOKEN WORD ARTIST

THEY ARE DRESSED IN ALL BLACK AND WE ONLY SEE THEIR FACES AND HEAR THEIR VOICES.

## ACT I – O.G.

SETTING: BLACK. SIMPLE. A ROOM IN A SMALL ROOM IN AN APARTMENT.

### CAST

N – A YOUNG BLACK MAN IN HIS LATE 20s/EARLY 30s

GOD – CREATOR OF THE KNOWN AND UNKNOWN UNIVERSE, IN THE FORM OF A THUG/GANGSTA, POSSIBLE AGE MID 20s

SET NOTES: SIMPLISTIC. TWO CHAIRS. A MIRROR FLOATS STAGE RIGHT. NEXT TO THE MIRROR IS A SMALL TABLE. A DOOR IS UPSTAGE TOWARDS THE LEFT.

## ACT II – FUNDAMENTALS

SETTING: BLACK. SIMPLE. A BATHROOM IN AN OFFICE BUILDING.

### CAST

I – AFRICAN–AMERICAN FEMALE IN HER LATE 20s
GOD – CREATOR OF THE KNOWN AND UNKNOWN UNIVERSE, IN THE FORM OF A WOMAN IN A RED DRESS AND HEELS, POSSIBLY LATE 30s EARLY 40s

SET NOTES: SIMPLISTIC. A COUPLE OF MIRRORS FLOATS STAGE RIGHT. A SINGLE LADIES' ROOM STALL.

## ACT III – GODCHILD
SETTING: BLACK. SIMPLE. PASTOR'S OFFICE IN A MEGA–CHURCH.

### CAST

S – MINISTER, MID–30s – EARLY 40s
GOD – IN THE FORM OF A NINE (9) YEAR OLD BOY
DEACON – LATE 30s
MRS. S – MID–30s
SET NOTES: SIMPLISTIC. A LARGE WOOD DESK. COMFORTABLE OFFICE CHAIRS. DOOR. MIRROR FLOATING.

MUSIC – PRE–SHOW MUSIC SHOULD BE A BLEND OF CONTEMPORARY AND TRADITIONAL GOSPEL MUSIC. (Mahalia Jackson, Shirley Caesar, Five Blind Boys, Andraé Crouch, Rev. James Cleveland, The Winans, Take 6, Yolanda Adams, Donnie McClurkin, Kirk Franklin, and end with Kanye West's "Jesus Walks")

### INTRO

> The stage is dark. A spotlight reveals the faces of THE CHOIR, ALTO, SOPRANO, and BASS, three people, male or female. They stand stage right, are dressed in black, and we only see their faces.

ALTO

Grace.

SOPRANO

Faith.

BASS

Mercy.

ALTO

Now I lay me down to sleep.

BASS

Our father.

SOPRANO

Who art in heaven?

BASS

Hallowed.

ALTO

Hail Mary.

SOPRANO

Be thy name.

ALTO

Thy name.

BASS

Thy... name.

SOPRANO

What is thy name?

ALTO

God?

BASS

Lord?

SOPRANO

Father?

ALTO

Jealous?

SOPRANO

I am?

BASS

Jehovah?

SOPRANO

Art?

ALTO

What art thy name?

SOPRANO

Who are you that we all seek?

BASS

That we seek, but have yet to find?

SOPRANO

We knock but ain't no one answering the door?

ALTO

Who are you?

BASS

Who are you?

SOPRANO

Who are you?

ALL THREE

We pray on our knees, just in case...

The lights Fade on THE CHOIR.

ACT I – O.G.
The STAGE is Black save for a single light reflecting on a mirror.

A GUNSHOT explodes in the darkness. The SOUND of a siren echoes in the distance.

Lights come up. N, dressed in a wife beater under a black hooded sweatshirt, jeans, and basketball shoes rushes into the room holding a gun. He looks out of the window. He's safe.

He feels the metal between his fingers. He's frustrated. Scared. Torn.

He turns and faces the mirror. N looks at his reflection. He casually looks at the gun in his hand. He is simultaneously repulsed and drawn to it.

                              N
                    (vents in anguish, but at no point does he get
                    loud)
God? God. God. God!? God. God...
                    (sighs)
God.

                    N sits in the chair. He slowly points the gun
                    to his own head. That's not the right idea. He
                    lowers the gun and lowers his head like a boxer
                    in defeat.

                    GOD, dressed as if he stepped out of a Hip Hop
                    music video, replete with Timberlands, comes
                    through the door.
                              GOD
                    (closes the door)
What's up?

                    N whips the gun around and points it at GOD.

                              N
Who are you?

                              GOD
                    (calm and cool as strawberry ice cream)
You should know. You called me.
                              N
                    (focused)
What? I don't have time for games. I didn't call nobody.
                              GOD
I'm not here to play games, but I think I know my name when I hear it.
                              N
                    (thinks about his words)
                    You're supposed be God?
                    (laughs)

Look, man, your monkey ass got 15 seconds to tell me who you are... I
got enough trouble as it is...
                    (under his breath)
Talkin' non–sense... I called you.

<center>GOD</center>

You did call me and quite loudly. And, son...

<center>(smiles)</center>

...you ain't gonna to shoot nobody.

<center>N points the gun directly at GOD's head.</center>

<center>N</center>

Nigga, is you crazy? Do you know who I am?

GOD

<center>(calm)</center>

I know exactly who you are.

<center>N</center>

<center>(arrogant)</center>

I'm sure you do. My rep is out there.

<center>GOD</center>

So's mine.

<center>N</center>

I seen you around here before?

<center>GOD</center>

No. And, do you mind lowering the piece.

<center>N</center>

I ain't lowering shit until you tell me who you are and what you want.

<center>GOD</center>

If it'll ease your mind, there's seven grand in my front pocket, you put the gun down, we talk, it's yours.

<center>N</center>

Seven thousand dollars?

<center>GOD</center>

All for you.

<center>N</center>

You gonna give me money? What's the catch?

<center>GOD</center>

No catch.

<center>N</center>

There's always a catch. Nigga don't just come up off of seven large for nothing.

<center>GOD</center>

I got a job for you.

                              N
A job? What kind of job?
                             GOD
One of the most challenging of your life.
                              N
Really? You bullshittin' me?
                             GOD
I don't bullshit. You want the gig?
                    N thinks about it for a moment.
                              N
Okay, let me see the money. And don't try nothing...
                             GOD
It's all good.

                    GOD reaches into his pocket and pulls out a
                    wad of bills. He sits the wad on the table.
                              N
Now step away from the money.
                             GOD
It's yours. Now let's talk.

                    N picks up the bills. It looks like it could be
                    seven g's.
                              N
Damn, you weren't lying.
                             GOD
I'm in the business of truth. I followed through on my part, now...
                    N looks at the money. He looks at GOD, not an
                    imposing figure. He could take him. He looks at
                    the gun. He could just shoot, be done, and keep
                    the money.
                             GOD
Don't even think about it?

                    N shares a look with GOD. He inhales, looks at
                    the money.
                             GOD
The reward at the end of this job is one that will be very valuable to you.
                              N
It will?

<div align="center">GOD</div>

No doubt.

> N ponders it for a moments, lowers the gun,
> and cautiously places it on the table next to the
> money. GOD nods.

<div align="center">GOD</div>

Mind if I sit down?

<div align="center">N</div>

For seven grand you can have the chair.
God sits.

<div align="center">N</div>

How'd you get in here anyway?

<div align="center">GOD</div>

I'm everywhere. In fact, while I'm here with your trigger happy ass, I'm keeping the universe in balance, the planets aligned, the Earth spinning, listening to and answering prayers, all while giving comfort to children in Africa with HIV...

<div align="center">N</div>

You got jokes.

<div align="center">GOD</div>

Do I look like I'm joking.

<div align="center">N</div>

Well, if you God... Why not just heal them? Just get rid of the whole disease while you're at it. Hell, why not just melt the gun in my hand or better yet, make it disappear.

<div align="center">GOD</div>

That's not how it works.

<div align="center">N</div>

You make the rules. So, that means you can change 'em, if that's not how it works.

<div align="center">GOD</div>

Not in the game plan, son. Once the rules were set, and we had tip off, I gave man free will. He was on his own from there... Game depends on his own ability to get the ball in the basket.

<div align="center">N</div>

So, you like a ref hanging out on the sidelines. Callin' fouls, blowin' a whistle, and shit. On the floor, but not in the game.

<div align="center">GOD</div>

You could say that.

N

But then that also makes you the commissioner and league owner. Ain't that like a conflict of interest?

GOD

Ain't no conflicts in this game_.

N

But if you perform miracles, isn't that like interference?

GOD

Only on a case by case basis.

N

So, you just drop miracles every now and then to let us know you're still around? Om–ni–po–tent? The great and powerful Oz? To keep the Munchkins singing... Keep us all in check on the yellow brick road.

GOD

I don't need to do that. You choose to follow your own path. Miracles are for... the faithful. Most of the time, I don't do jack. I gave you all the power you need.

N

You sayin' miracles ain't real?

GOD

Oh, they're real, but only if you believe. Miracles are happening everyday. Miracle of birth. Flowers in Spring. Space flight. Separating conjoined twins. There's even the miracle of death.

N

Death? Death ain't no miracle. We all trying not to die. Why not let us live forever?

GOD

Because you couldn't handle it.

N

If I could be young and live forever, I'd be rich?

GOD

I gave Methuselah that chance and he said he couldn't take any more, just to see how long... Watching all his friends and family die while he was still living. Eats at you. Living forever can be a bitch. So now, you're born, you live, and your body dies, but the spirit lives. It's in the contract.

N

Contract? Nigga you crazy. You been hanging 'round Pastor Johnson up at New Hope, ain't you?

                                GOD

Ah... Pastor Johnson with the alabaster Benz and the pretty wife and
seven children by women in his congregation. The same Pastor Johnson
who takes a little off the top from the collection plate despite all the
"love" offering he gets every Sunday, and who goes on television and
tells people if they send him fifty dollars he'll pray for them. That Pastor
Johnson?

                                N

Ummmm... Yeah.

                                GOD

Naw. I don't hang with that cat.

                                N

People seem to think he got your ear and that you speaking to him.

                                GOD

Everyone who speaks to me, don't speak for me. Preachers, Rabbis,
Monks, Clerics, Imams, politicians, doctors, entertainers... They all think
they know what it takes. They all think I sanction their every belief.

                                N

I guess you can't huh?

                                GOD

Truth is, they don't want to carry my true message. Then they would be
out of a job. Shit, not even Lucifer wants my job.

                                N

He don't? I thought that was the purpose of the whole beef between you
two. He wanted to be top dog. You kicked him out of Heaven on his ass...

                                GOD

Hell no. Lucifer... That kid just loved to be contrary. He liked the easy way
out of everything, lazy rat bastard. Shiftless. Never wanted to work for
anything, but liked to stir shit up.

                                N

Seems like he works hard trying to bring you down.

                                GOD
                             (smiles)

Ironic, isn't it. All the shit he did just to throw monkey wrenches. Truth
be told, Luke is pretty much hands off with petty sins.
                             (sotto)
You don't need him for that anymore.
                        (holds back laughter)
He's gone corporate. Got condos in Rio de Janeiro, New York, Berlin,

Macau, Dubai, Las Vegas, Amsterdam, Tijuana, Capetown, Manama, Moscow, and Pattaya. Specializing, he says. Diversifying. He's mostly thriving on rep, with an occasional push, but he knows he'll never win.

(laughs)

Now, that's Hell. Ha!

N shares a laugh with GOD.

GOD

Everything Luke's putting down is easy. Greed. Hate. War. Havoc. Robbing, stealing, killing... All that stuff is easy to make happen.

(a beat)

Try loving. Love. That shit is hard. Compassion. Empathy. Love takes work.

N

Then why not take the him out. If you're God, you can start over. Remake the Garden without the tree this time. No tree, no sin. Presto... Back to perfect world.

GOD

(rises)

Perfect world? What's wrong with you? Ain't you been listenin'? You don't get it?

N

Get what?

GOD rises, paces for a moment, side eyes N.

N

Get what?

GOD shakes his head.

N

Come on, spill it.

GOD pointedly gets into N's face, shakes his head.

GOD

The world is already perfect, son! I'll be me-damn.

N

It is? There's famine, poverty, war, disease... What's so perfect about that?

GOD

I may have made you in my image and likeness, but damn, you can be dumb sometimes. There's perfection in what you conceive as imperfection. There's a reason the Earth revolves around the sun. Not the other way around. This little planet is part of a system.

(laughs)

Balance, kid, balance. The universe is alive. Do you think everything revolves around man? Arrogant motherfuckers.

N

What!?

GOD

You heard me. The things you do to get attention. Nothing else I created bitches as much as people. There's a reason and purpose for human beings, dogs, whales, and dolphins just like there's a reason and purpose for earthworms, cockroaches, leeches, and tardigrades. There are creatures men may never see that serve a purpose. Get over it.

(loses his cool)

Just because you choose to wallow in misery don't mean the world isn't perfect. Do you know how long it took to get the ozone layer right? And you people have managed to mess that up in less than 100 revolutions.

(voice echoes slightly)

Look at what you've done to the oceans. Pollution and fishing. More than half the life that was there is gone... In less than 50 trips around the sun. Glaciers are melting... Every time I make something, you find a way to fuck it up! Perfect world my ass. You broke it, you fix it. I'm tired.

GOD pulls out an inhaler and takes a deep breath.

GOD

Now you got my spiritual pressure up.

N

(bowing his head)

Sorry. I didn't mean...

GOD

Sorry don't cut it anymore. You know what I can do when pissed off.

GOD pulls out a blunt which is already lit.

N gawks with a surprised look as GOD takes a puff.

N

Is that a...?

GOD

Blunt? Weed? Joint? Spliff? Mary Jane? Marijuana? Yes. And it's 100% South American homegrown. You want a hit.

GOD inhales and makes smoke rings. N watches, shaking his head.

                           N
If you God, why you smoking a blunt?
                          GOD
Why? Why not? Not like it's gonna harm me. When I take human form,
I like to feel what you feel. Why should I let Junior have all the fun? All
the wine he drank...
                    (inhales)
So, you want a hit or not?
                           N
Yeah. Why not...
GOD
                    (hands the blunt to N)
Careful... This is some strong shit.
                    N takes a strong hit and coughs violently.
                           N
                    (coughs)
Jesus... Christ... What the...
                          GOD
                    (looks up)
I got this, Son. You can continue what you were doing.
                    (re: N)
You must got some serious problems. First you call me, then my boy.
                           N
I wasn't ready for...
                          GOD
Just breath in deep. Get some air in your lungs.
                    N takes a few deep breaths. He settles down.
                          GOD
There you go. Now relax. Take another hit. Slower this time.
                    N inhales the blunt slower. This time he handles
                    it like a pro. He hands it back to GOD.
                          GOD
Thanks.
                    (they both relax, share the blunt)
Nice.

                    They take a few more hits as the SOUND of Ben
                    Harper's "Burn One Down" plays for a moment.
                    N turns and faces GOD.

                              N

So, why don't you do a miracle?

                             GOD

I'm here talking to your black ass, right now, fool. What more do you
want?

                              N

You got a point there. So, what you doing cussing and all that then? Ain't
you supposed to be "thee and thou" and all that...

                             GOD
                         (Spanish)

Language is simplemente una herramienta.

                         (French, switches languages without blinking
                         an eye)

N'essaye de l'apporter au niveau du peuple.

                         (Portuguese)

Eu nÃ£o sou algum guy que senta–se em um throne que acena um wand
mÃ¡gico.

                         (German)

Wenn Sie dieses dann wÃ¼nschen, beten Sie Zeus oder Jupiter an.

                         (Italian)

Non rotolo come quello.

                         (Dutch)

Ik ben de echte overeenkomst.

                         GOD then speaks in "tongues" for an instant.

                              N
                         (confused)

What was that?

                             GOD

My bad. I said, language is merely a tool. I try to bring it to the level of
the people. I'm not some guy sitting on a throne waving a magic wand. If
you want that then worship Zeus. I don't roll like that. I'm the real deal.

                              N
                         (dumbfounded)

Oh.

                         N takes another puff of the blunt and passes.
                         GOD puts it out and then turns and studies N,
                         who is enjoying his high, for a moment.

GOD

(serious)

So, you ready to talk about why you called me?

N

I didn't call you, man.

GOD

Yeah, you did, so let's rap.

N looks at the gun sitting on the table. It leaps off and slides across the floor.

GOD

You wanna talk, nigga, let's talk.

GOD stares N in the eyes. N sees something that almost wants to make him breakdown and cry. It is a vision? A thought? Pure love? He turns and looks at the door.

N

Ok. It's my son. My son... I need money to... Aaarrrghhhh... I can't even say it.

GOD

You don't have to. I already know.

N

Then if you know, then tell me what to do.

GOD

I can't do that. I only came to talk.

N glares God, indignant.

N

Then what the Hell you come here for?

GOD

You tell me. You ca...

N

...I know. I called you. You know something, fuck it... Now that you here, I do have a few things to get off my chest. You picked a fine time to come here you know that. Where were you when I was nine and Carl Johnson was kicking my ass? Just because my chair bumped into his. Where were you when I was arrested by the police and had to spend three nights in jail for something I didn't do? Where the fuck were you when my father was dying of cancer? Suffering. You know what that was like? Huh? Where were you when... Fuck it... What's the use? And now you decide to come? I can't save my boy and evidently you not gonna lift an almighty

finger to do so either.

GOD

You finished?

N

Yeah.

GOD

I don't know what's worse your arrogance or your stupidity. I was there when all of that shit went down. I was there when you cried yourself to sleep when you wet the bed. I was there when you called my name every time you got laid and conceived both your kids. I was there when you were in college and read the Bible, Koran, and Torah just to find answers. I was there for every significant and insignificant event in your life. Just like I am here now...

N sits back defiantly.

N

You were there when...

GOD

...You took the Boston Baked Beans and Baby Ruth bars from Mr. Lee's corner store while his back was turned.

N

How about?

GOD

You smoked your first joint with your cousin James at the family reunion in North Carolina.

N

And?

GOD

When you had sex with, Zita Jones, your best friend's girlfriend and said, this will only be between...

J

You, me, and God.

GOD

...you, me, and God.

N thinks back on these things. His own life. He gets weak. Who else would know these things?

N

When...?

GOD

You cursed my name on June 7th, seven years ago when you couldn't get

70

a small business loan to start a mobile glass company.

                              N

What about...?

                            GOD

You sure you want to go down that path?

                    GOD smiles. N ponders for a moment and
                    wrings his hands.

                              N

Damn, you must really be...

                            GOD

What do I have to do? Give you a business card?

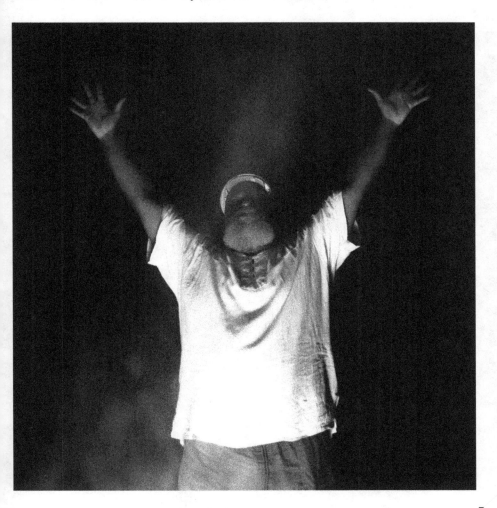

# Augustus Browning II

Augustus Browning II is a photographer and former member of Sun Ra Arkestra where he played the French horn. He currently has a permanent collection of photographs at the Smithsonian Institute's Eliot Elisofon Photographic Archives, National Museum of African Art. Augustus spends his free time taking nature photos along the Shonan coast in Kanagawa prefecture, where he currently lives.

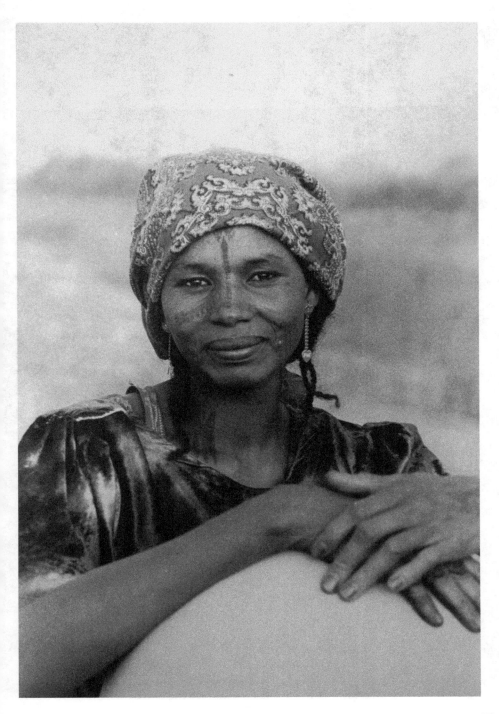

74

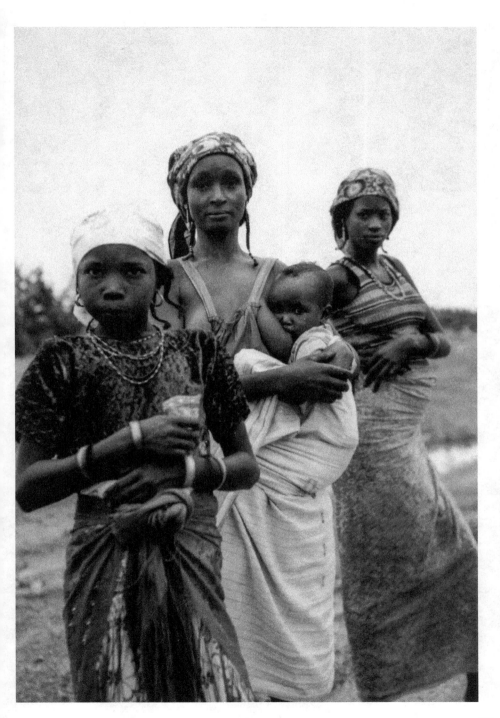

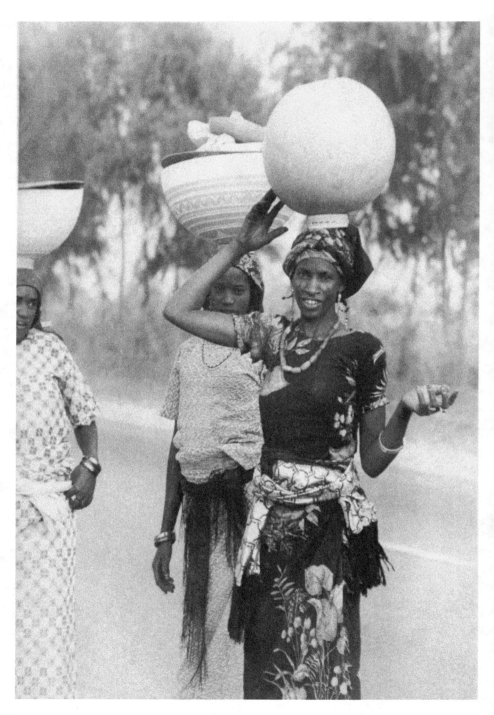

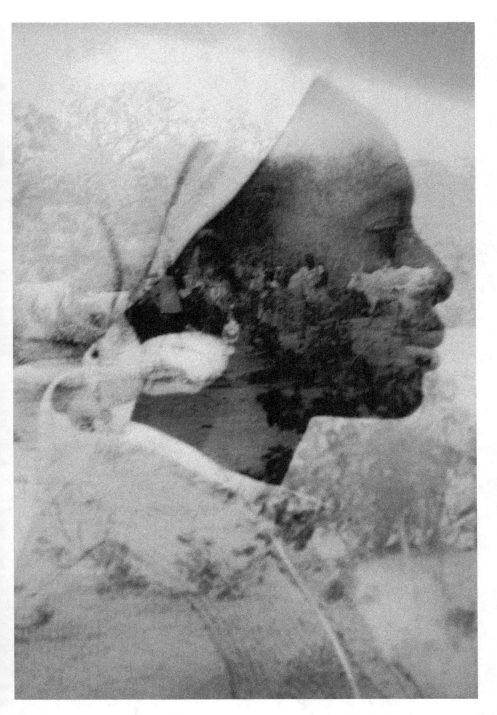

# Frances Dyers

Frances Dyers is a 28-year-old South African woman who has been living in Japan since March 2018.

"In South Africa, my African heritage was never questioned because so many people in Cape Town look like me. It was only when I started travelling that I had to defend my identity as a native African and the perception of what "black identity" means outside of Africa. I found comfort in the women of the African diaspora where, despite different cultural backgrounds, our blood gave us shared experiences in this world that united us.

I've connected with more people from other African countries and also learned more about African-American culture during these past three years that I have been living in Japan than at any other point in my life. This has greatly impacted how I see myself and my place in this world. I didn't realize before how much I hated myself because I was always comparing myself to euro-centric standards. This growth has put my life on a new course. There's now so much self-love in my heart. I hope to show everything I've learnt through my writing."

Quote: "You might be pretty
　　in your country.
　　But you're not the pretty
　　that Japan wants."
　　　　– Successful white model. Tokyo, 2018.

## Modeling in Tokyo

And in this room, with its white walls,
I stood out enough to be hidden away.
The foliage of my hair offering shade
to the woman who reached up to its splendor,
and dug to its root to apply her poison of,
This is not what we're looking for.

I smiled brightly
despite my leaves falling to the ground
in this never-ending autumn
Where I'm reminded that
Hey
at least
it's no longer winter

And yet, I find myself standing in the cold
looking up at the billboards
of those who stole the light of our sun
to shine upon themselves as they look down on us,
with all the glory of a Walmart deity
and wonder

"Why don't they shine as bright as we do?"

# Dess Spence

With roots in Calgary, Alberta, hopes and curiosity took Dess from the West of Canada to Montreal and then Toronto. All smirks and smiles, this second-generation Jamaican Canadian loves hard in family, friends, and art. Be it video work, design, or poetry, Africa (Dess) has always had a need to express.

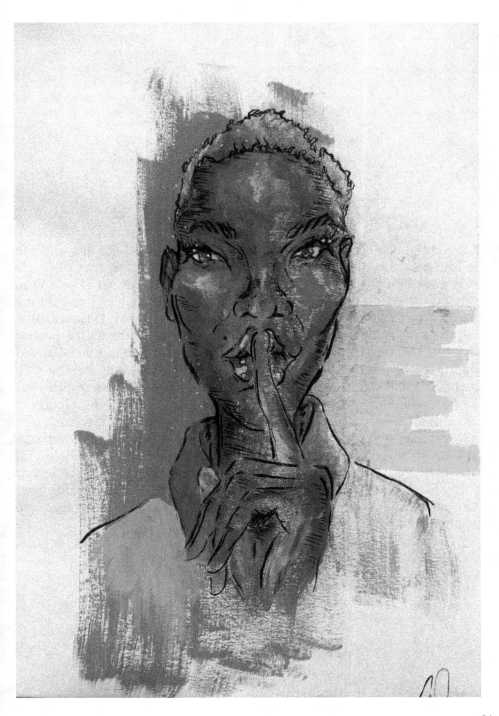

# Amadou Tounkara

After a detour to the law faculty of Dakar, he turned to the fine arts and graduated from the National School of Fine Arts in Dakar in 1998. He was selected for the Biennial of Contemporary African Art (Dak'art) in 2010 and has produced numerous exhibitions as well as live-painting performances with internationally renowned musicians and visual artists. His work bears the traces of his studies of very diverse practices: Japanese painting (Nihon Ga), graphic design, computer graphics/multimedia, and digital textile printing, in particular dyeing work. Especially interested in architecture, he often depicts doors and windows in his paintings. He thus intends to create openings on what is beyond, an "outside" in relation to an "inside" which is also part of our actuality: a pictorial mechanism to allow the artist as the spectator to engage in an analysis and an evaluation of daily habits, cultural and historical questions, signs and symbols, and above all the transformations / evolutions that are taking place in our societies. It thus invites us to launch a reflection between an "inside" and an "outside" and "crossings / borders", as well as on the symbolism and aesthetics that they represent.

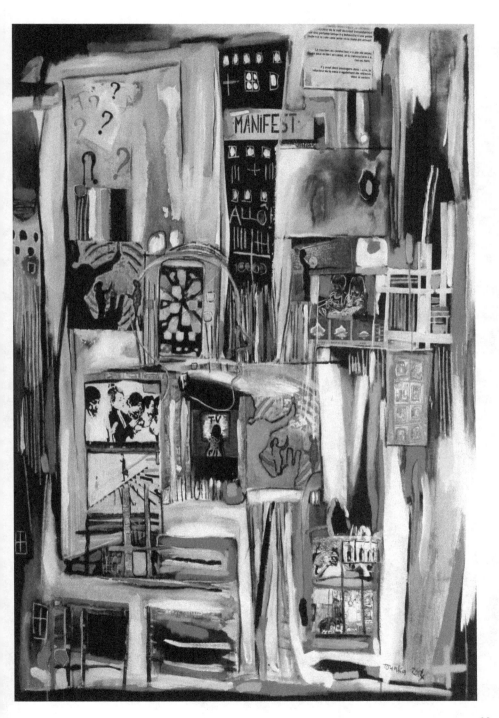

83

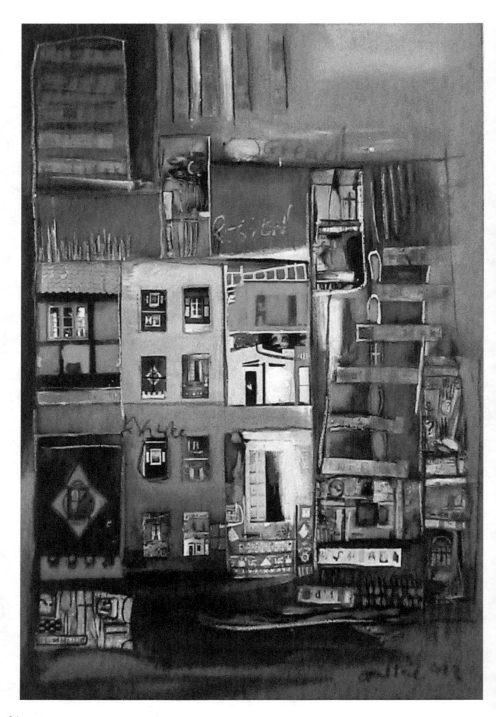

84

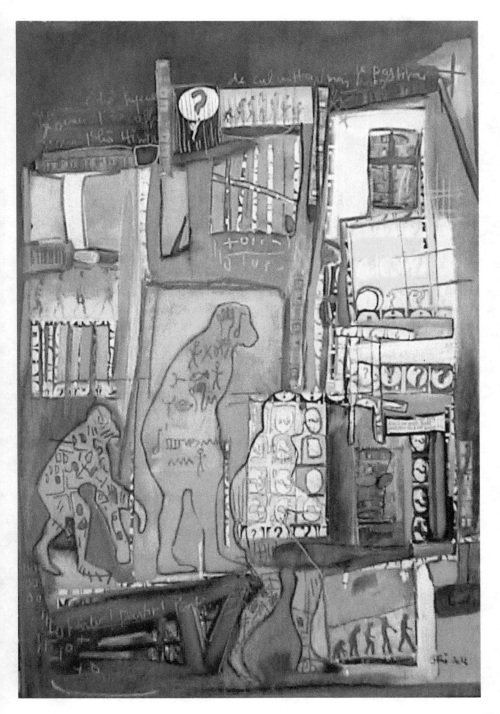

85

# Ivory Bennett

Ivory Bennett (she/her/hers) is a published millennial currently working in Dallas, Texas. She is a Pittsburgh, Pennsylvania native and former foster youth with 17 years of lived experience. Ivory also has Type 1 Diabetes (also known as Juvenile Diabetes)—a motivating factor behind her passion for the healing potential and power of art, especially writing. She credits art, a love of learning, and a passion for literacy to her success.

Ivory has a Bachelor of Arts dual degree from The University of Pittsburgh in African Studies and English Literature with a minor in Theatre Arts (Performance). She also has a Master of Education Administration. She is an aspiring Doctoral student. Recently, she was a dual-accredited English teacher and cheer coach at a Title 1 Collegiate Academy. Ivory is excited about her new role as a Manager of Teacher Leadership Development with Teach for America: Dallas – Fort Worth.

Outside of work and writing, she has a strong commitment to education equity and foster care advocacy. Ivory loves to travel internationally, try new vegan dishes, and tend to her plant-babies.

## When Women Prey

There are women whose
breasts have been
weaponized
against children.

Whose hands hurt
more than they heal.
Whose fingers land
like daggers on
unsuspecting innocents.

Whose lips carve craters
wherever they land.
Whose words cast spells
of insidious suffering.

Whose wombs are
wrought with encrypted
etchings of the
grieving ghouls,
lured there by the
pretenses of promise.

When women prey,
they baptize their pillaged
in carnal, crimson-
clad canals.

It always takes me aback.

## The Artist

Look.
I still bear the marks he
molded into my skin.
Crafted melanin.
I am his statue.

He says the crack he placed
over my lip
was his special touch –
to remind me that he owns
my laughter. My voice.
Any song I've sung, he orchestrated.

He tells me,
while he wraps his thumb and fingers around my neck
to direct the ebb and
flow of my breath,
that he owns that, too. My wind.

He's given me great poetry.
And I've given him
bone and flesh.
Blood and beat.
Breath and body.

# Nicole Alston

Nicole Alston is an artist and visionary who uses platforms from fashion, spirituality, and writing to express herself. She is a self-published author of Little Black Book of Love, Her Love Language, I'm Just Like You Journal, In Mama's Shoes, The Lover's Dictionary, and #twentyeight. Born and raised in Baltimore County, Maryland, Nicole is well versed in all things creative. She has been featured at the Baltimore Book Festival as well as other lifestyle events. Aside from writing she is also a freelance Wardrobe Stylist. Previously nominated for the Fashion Awards MD as "Best Emerging Wardrobe Stylist", she was also featured in two Raw Artist Fashion Shows. Since fashion has been one of her passions, Nicole created "Hey Sis", a branded t-shirt designed to bring women together and unify. Nicole is a photographer and a host of "Bougie Ears", a culture + music podcast. Her mission on this earth is to cultivate herself and others through her various forms of art. She is a mother of three, enjoys listening to 90's r&b, hounds-tooth print anything, and singing.

## Beauty is made up of synchronicities.

I find it odd that I can often become intimidated because of who I am not. But who I am bleeds confidence. Comparison and contrast come from computer screens. Instagrams and imageries. Insecurities come from generational themes. But we break curses, we elevate and flourish.

Yet, still beauty is made up of synchronicities. Gifted and talented only had select children. I know now that being a goddess isn't a choice, it was ordained, a god right selection. Did I forget to mention that I am who I am because I am a product of my ancestors. It is my birthright to have influence and insight.

# Adekeye Oluwasegun Lukman

Adekeye Oluwasegun Lukman is a student of the University of Benin, Benin City (in affiliation with Delta State College of Education, Mosogar), Nigeria, where he's currently studying English and Literature (Ed). He is a member of the Association of Nigerian Authors (ANA), Delta State chapter, and the president of the Creative Writers Association (COEM chapter). He was nominated for The Arojah Students Playwright Award 2020.

# THE COMING OF AN ICON
For Delta State College of Education, Mosogar (08 March, 2021)

I came in with wuruwuru
Me, under the feet of the state government.
I came in like a lamb
De only one of the war survival,
Enduring the limited time.

I
May come in like a lamb
I may be gentle and look cool like
De man who fall from stories building, and
Enduring this juvenile hard time patient

But you just watch and see,
Enduring time last for a limited time.

I will be back in due time like a lion
Me ruling you like a strict war general
Intending to set war and count the survival
Depending if there is any.
Ever lasting is my rejoice.

## The Caged Voice

I was born to talk
To make no rest to my silly mouth,
To swee and swee from dawn to dust
And make merry over my loquacious nature,
But they want it not.

Listen,
I speak not of false but the truth.
I became their pen that write just what they intend
Just what they feel
And just, just that they write.
I only show just what they make me to show,
But they want it not.

I wished to fly across the globe,
To fly so high with my voice echoing
From angle to angle and edges to edges,
I wish to shake my tail in ecstasy
While I make men free from agony,
But they want it not.

They placed my happiness just beneath their foot
And my joy danced in their mystical cage,
They set my life free but caged my soul,
They make me say the truth to myself
In my critical desperation
And shook my tail just in a spot,
They made my heart ache
And danced in plenty agony.

They want just my voice
But not its relevance.

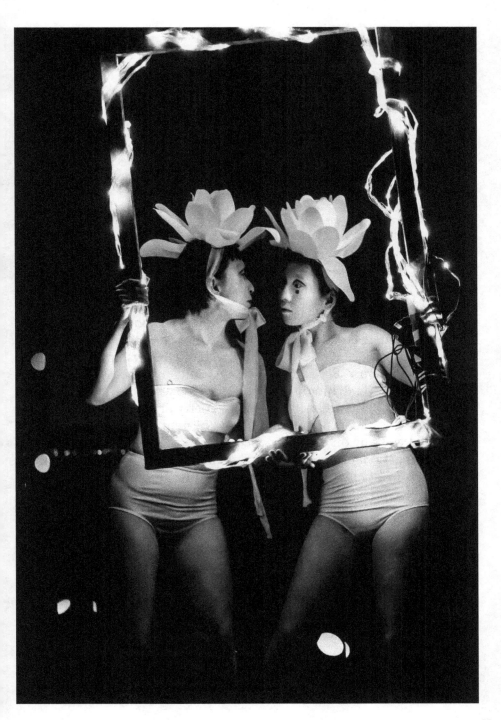

# Michael Frazier

Michael Frazier is a poet & educator living in central Japan. He graduated from NYU, where he was the 2017 poet commencement speaker & a co-champion of CUPSI. He's performed at Nuyorican Poets Café, Lincoln Center, Gallatin Arts Festival, & other venues. His poems appear or are forthcoming in Poetry Daily, The Offing, Cream City Review, RHINO, Visible Poetry Project, & elsewhere. He's received fellowships & residencies from Cave Canem / EcoTheo Collective, Callaloo, The Watering Hole, The Seventh Wave, & Brooklyn Poets. His poetry has been honored with Tinderbox's 2020 Brett Elizabeth Jenkins Poetry Prize, as well as Pushcart Prize & Best New Poets nominations. Now, he's curating poems for Button Poetry, and working on a poetry collection about his mother & oyakodon. He's uber passionate about anime, bubble tea, and, most importantly, the power of Christ to change lives. He also facilitates a biweekly zoom poetry book club open to the public.

## My Mother Says, Don't Come Back to America, Cause You're Safer in Japan

*You'd miss me too much if I stayed here, I say.*

*Who said I was going to stay in America? she laughs. I'm saving up for my ticket now. I'm choosing grandma's nursing home. I'm shipping your brother all his junk.* And we both laugh.

### 作家

Earthquakes, tsunamis, volcanic eruptions, typhoons, torrential rain inducing mud slides, roof-caving snowfall, murder hornets: my fears are different here. Even if nature does kill me, I'm collateral damage, not the pinpoint of its ire.

### 作家

Here, I will never be called out my name, because the language is not built for that type of violence. Only the moon or mosquitoes follow me at night, and even if I'm stopped by the police they don't have the means to gun me into a headline. I can walk in and out of a convenience store, with a hood on, with my hands in my pockets, and still be thanked for coming.

### 作家

*I feel guilty. I tell my mother. What am I doing for the black community? How am I helping?*

*You alive ain't you? she asks. You got them poems, students, and your church, right? Black people been dying in this country since before you were born, whether you here or not that won't change.*

### 作家

The hydrangeas are green and not yet a spectacle. I trace the Japanese characters 作 (make) and 家 (home), the characters for author. I read aloud Afaa Michael Weaver's "Theme for Intermediate Chinese." In my kitchen, I cut the watermelon flesh into neat small squares, and squint at the sun as it's lowered into the ground.

## 作家

None of the other American expats feel the way I do. Everyone says the same thing: *We're so lucky to be here instead of there.*

## 作家

My mother calls thirteen hours into her future to ask me what's going on in Rochester. She stopped keeping up with the news somewhere between Breonna Taylor spread onto a billboard, and Daniel Prude snuffed out around the corner from her hairdresser. I tell her what they're saying about the mayor. Where the protests are being held. What neighborhoods to avoid.

## 作家

Before entering the classroom, I spray each of my students' palms with a hand sanitizer spray bottle, the type you'd use to clean windows. I point the nozzle at two boys and they stop, raise their hands and shout, *don't shoot!* I forget to laugh. Later my principal asks, W*ith everything going on in America, how are you doing?* And I say, *I'm here.*

## 作家

The day after George Floyd's funeral, rainy season began. The air was humid, the sky clotted with clouds. We waited all day for the rain, and when it came, a dirge that lasted for an hour, then the sun, as if to say something.

## 作家

*NEGRO AUTHOR ASKED TO LEAVE JAPAN BY POLICE.* I'm reading Hughes' autobiography along the Asano river. I'm underlining the sentence, *I, a colored man, had lately been all around the world, but only in Japan, a colored country, had I been subjected to police interrogation and told to go home and not return again.*

## 作家

We agree that she shouldn't have called the police when she returned home and saw the door ajar. *But what else was I supposed to do?* my mother asked. *I'm a woman. Everyone knows I live alone. Who was I supposed to turn to?* Both of us aware of what could have happened if an officer confused her for what he was looking for.

## 作家

*No, I don't have any weapons,* I tell the police officers in Japanese. *Yes, I live here. Yes, I have a job. No, I don't have any drugs. Here is my citizen card.* As I bite my tongue, I think, *would you like my blood?*

## 作家

*They just want to touch your hair. They just want to rub your skin. It's just black face at the staff Christmas party. It's just black face on national television. Nissin only whitened Naomi Osaka's skin to sell more ramen. You only know one person who's been told to go back to their country. They mean you're scary in a cool way.*

## 作家

Mom, what is safety? Is it a country? Does it live inside four walls? Is it a feeling? Is it a song I can fall asleep to? Is it in my body?
Can it be taken
without my permission?

# Mikail Terfa Akundu

Mikail Terfa Akundu is a Nigerian, born on December 22 1976, to Christian parents, Sylvester and Ruth. He undertook his degree program from 2002 to 2008 where he obtained an LLB (Hons) with a Second class lower division at Ahmadu Bello University Zaria – Nigeria. He is a Muslim and happily married to a Christian wife, Fibi, and they are blessed with a boy and a girl. He is a certified member of the Creative Writers Club, Ahmadu Bello University Chapter (2002 to 2008). He is the recipient of many certificates in different Poetry and Writing societies. Although Mikail Terfa Akundu has not published any of his works, he has quite a number of unpublished poems and is currently writing a book. His interest in writing is intense, spanning from 2019 to date. He his currently writing his autobiography.

## Fray Not Dear Bulgarian Rose

The sun graces its shine
in the wonted epical mannerism
of goldish radiance
on Earth's massive face.

The dead love
in the afore-dark night
awakens and springs
on the wheels of hope
It's the feat of the evasive twilight.

Doors clattering
Engines combusting
Ushered are men
Unto their day
and their ordained duty's designates.

Sunlight bears the torch
to the path of dreams
cast upon the vast sea
of life's terminal toil.

The long bare foot walk
on the hot sand in harsh toil
unregistered to mind
At Nature's course I murmur not

Earth's space shrouded
in darkness again
and life goes to bed
and reawakens
to the recycling procession of sunrise
and dreams pursuit.

Midday comes with traces
of wrinkles on my skin
The harbinger

to a waning twilight and dusk fall.

In all
I've saved
to settle my original debt with earth

Only a lame and unyielding resistance
do I muster in repayment
as after all
I'm lowered to earth
in submission to my rare quietus

## So I Can Fly The Kite Too

I want to render my nursery rhymes
like the other child nextdoor

The taunting cow's gored me out of school
and he's nudged me away from accustomed
playground too

I'm lush ground on which to grow seeds
of malleable ornaments and more
hence my mind's mines abounds
in hoards of diamonds, gold, silver and ore
so I beckon in endless petitions
the miners' intrepidity to mine

More than a fantasy
the caressing palms of my mother
cast spells of blue-ribbon dreams
this external morbid bud
should spring awesome leaves
and vaseful flowers
of a rewarding adulthood.

Beyond this veiled reality
I'm a father and even a mother
by humanity's requital in the coming days

Beyond the pessimist's transience
this blunt-blade-autuism you can hone
to cut stereotype bounds and chains
a chance to live you can give hence

I want to read my life's rhymes
like the other man nextdoor
like the other woman nextdoor

## Tantrums

Paired in millions with my kind
in the Inseverable pact
of dubious bureaucratic crass and curses
Locked we are in a cocoonic prison
of a stratum on the edge of volcanic tantrums

My hand of naivety to a cunning pact appended
Now a suspicion's vulnerable __ an ensnared felon
The waged dogs on the watch snarling
or locking my ankles in their incarcerating jaws
Canned in mournful prejudice
is my slightest cry for justice and equity's
oughts

Hunger dwells with the feebled indigents
Paucity adorns with rags
Disease strikes to death
My pain their gain
My joy spent in a relishing squander
of the baitlmal against welfare

Oscillating in the cramp
of institutional stings and stenches
komorebi of salvation flees
from my despondent grimace for freedom
Eyes darting
breath pacing fast

Stunned in the chute
awaiting the slaughterer's knife
my neck to slit

Honed by the malice
of injurious social equilibrium's dearth
my imposed devil's claws wrecks a rip
of their hearts in eerie daydreams
I want their hearts and heads
for dinner at freedom's dawning tables

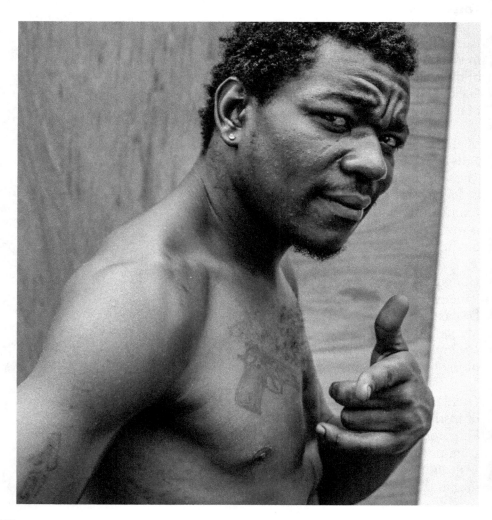

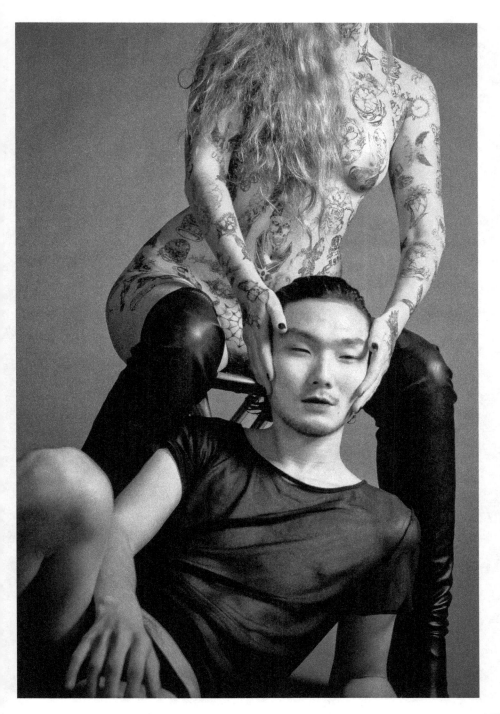

# Nwankwo Columbus Chinedum

Nwankwo Columbus Chinedum is a 300 level student of Nnamdi Azikiwe University Awka, Anambra State, Nigeria, from the department of Agricultural Economics and Extension. He is a native of Enugu state. He is a lover of poems and has written many. Why We Wailed is one of his works, inspired by the just concluded school-wide protest against exorbitant increases in school fees by the management of his university.

## Why We Wailed

He came to us wearing rumor
His garment at blink,
Glowing tints of truth
Truth growing worries
In our hearts as tumor
So we wailed

Be he sent aback
Pulling down his tent
Before it is pitched
Getting rid of his claws
Ahead his perch
So we wailed

His arrival gathered anxiety
So high in the cloud
Waiting who then will
Bell the cat
In a society where voice
Leads a gateway
Behind the bar
But better not to wail
Than drop off the part?

Then he came,
Bold to drag the bull's horn
And on his boldness
Warriors raised among weaklings
Warriors armed to the
Tooth but with placards
Placards painted pains
And wail

Million voices in a message
Round the nooks and through

The crannies of her wall
The sun left our side
Our flesh it sear from
The happy cloud above
Yet we marched
Round and round the clock
Till marched down that
Voice from above

Voice so smooth as wool
Amidst our wail
As it reassured.

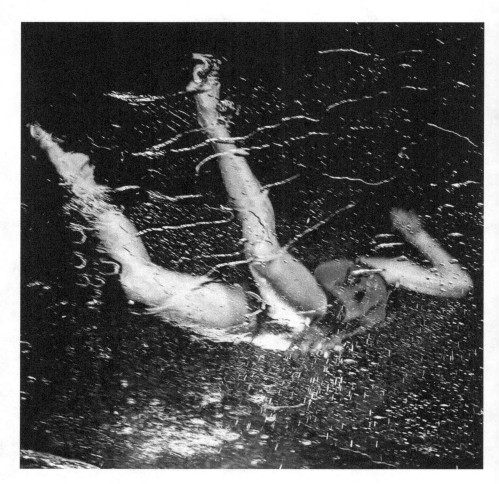

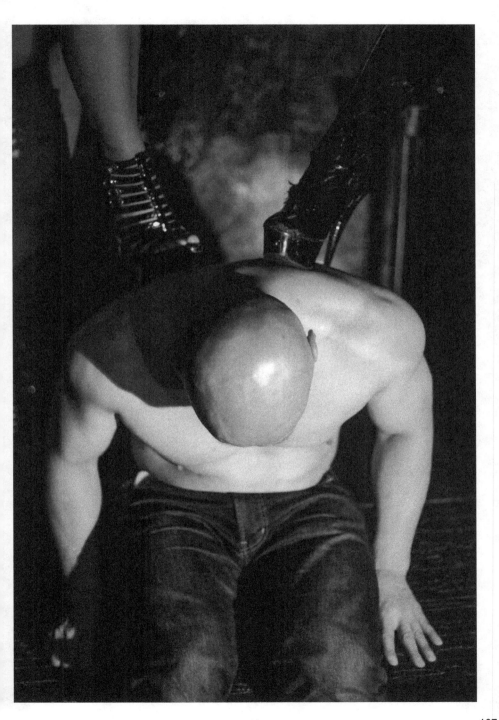

# Gerald Headd II

Gerald Headd II is a constantly self-reflective fly on the wall and keen observer of the intricacies of human behavior, which is often expressed in his writing. Whether planned or spontaneous, he is usually motivated by an array of things from art, music, and film to social interactions and thought-provoking conversations. Although he's not listed as a New York Times bestseller, he jokingly thinks it to be true somewhere in an alternate universe. As a growing world traveler, he values the importance of silence and being one with nature and continues to remain in awe of Henry David Thoreau's "Walden" (aka "Life in the Woods").

Left Unsaid

Words pop like kernels
only to meet the top lid
never to grace the lips of
the maker falling on
deaf ears if they were
ever to surface but the pot
has no regard or courage

surely the letters have
combined to form
patterns yet they are
destined not to be
discerned properly the
sequence buried in
oil so deep that
vowels are drowned
out by consonants

poor little ones
struggling beneath the
crowd wiggling their
way to the surface only
to tumble back to the
bottom the heat has
simmered and the stove
has taken its last breath

# Mónica Lindo

Mónica Lindo is an Afro-Latina with a passion for seeing new places, meeting new people and learning about their cultures. She taught American Literature, British Literature, and Spanish at public high schools in Connecticut and Washington, DC, U.S.A before moving to Asia (South Korea and Japan) where she has been teaching since 2012. Her next destination: West Africa!

## "Do you like bananas?"

After school I was killing time at my desk before going to the bus stop. All the staff were in other parts of the building, so it was just the school secretary, Arisaka-san, and I in the office. She came and asked, "Ms. Lindo do you like bananas?" I answered yes, she pulled one off a bunch and handed it to me. She hesitated, then said something in Japanese. The only word I caught was 'monkey.' Seeing that I didn't understand, she paused and said something else. I still didn't know what she was saying. She then tried again, this time she mentioned "trap" and Kanda-san, the school caretaker. Finally, I understood, and contently peeled the fruit and ate it.

\*\*\*

Up here, in the mountains of Gunma, groups of men hunt for bears, boars, monkeys, and deer. Kanda-san's hobby is hunting. Earlier in the week he had gone hunting for monkeys, and had bought bananas to put in the traps. Afterward, he'd brought the unused bananas to share with the school staff. This was what Arisaka-san had been trying to explain.

Later, while chuckling about how the secretary and I manage to communicate with her limited English and my limited Japanese, it dawned on me that this interaction could have gone south really fast if I had hastily jumped to conclusions. Often Black people, particularly those from the U.S., carry racial baggage with them to other countries. Some walk around on high alert expecting to find racists under every rock and behind every bush. And that colors their interactions with everyone in a crippling way. This is not to say that racism doesn't exist out in the rest of the world. It means that when we board a plane, ship, train, bus, or rocket to anywhere, we must make an effort to leave unnecessary baggage at home. Our experience abroad will be all the richer for it.

June 2019

## Cilantro

I live in a tiny mountain village in Gunma Prefecture. How tiny? Population: 1300. There are no convenience stores or supermarkets. So I usually do the weekly grocery shopping on Sundays on my way back from spending the weekend in Tokyo. I normally plan it so that I have at least 30 extra minutes to shop before I hop on the last van of the evening. Today I was having such a good time at the Earth Day Festival at Yoyogi Park that I barely had enough time to make my train-train-van connections, which meant no time to shop.

I'd been wanting to make potato-channa curry for the last two weeks, but twice the supermarket had had no cilantro. Curry must have cilantro. I'd hoped to get some today, but couldn't, so I decided to ask Ine-chan, gardener extraordinaire of flowers and edible plants. My neighborhood has two small shops that cater to the visitors who come on weekends from out of town to hike, fish, camp and do other sorts of outdoorsy activities. Fukudaya is the one closest to my apartment, but they are price gougers and Yamagata-san, its owner, is an evil man who doesn't deserve my money. Ine-chan is the lovely owner of Kaneto, the other little shop ten minutes up the hill.

When I got on the van, the driver told me that my hair looked cool. It's just fat twists, I thought to myself. Then I realized that it had been six months since he'd seen my hair because I'd been wearing a hat since October. On the mountain winter comes early, and leaves late and grudgingly (it snowed all day on April 10th). When I got off the van at 8 p.m., I stopped in at Kaneto. Ine-chan and her husband were lounging under the kotatsu in the side room attached to the shop. He looked away from the television long enough to smile and wave his cigarette at me. Ine-chan greeted me, sat up and chuckled while she put her teeth in. *"Pakuchi wa arimasuka?"* I asked. She thought for a moment, put on her shoes,

grabbed a knife and said *"Chotto matte kudasai."* She walked out the front door and disappeared into the darkness across the street.

A few minutes later, she returned with a large bunch of fragrant cilantro in her hand, earth falling off the roots and water dripping off the leaves onto the concrete floor. As she rang up the carrots and cucumbers I'd laid on the counter, she said that there was no charge for the cilantro. I didn't understand the sentence after that, so I didn't catch the reason why. Probably because I'm the only one who's ever asked for it. Or because it probably just sits in her garden waiting to be nibbled on by rabbits and deer. At any rate, I would have been willing to pay double the going price for it, but she gave it to me free because Japanese cuisine doesn't use cilantro. *Arigato gozaimasu* and *itadakimasu!*

------------------------------

*Pakuchi wa arimasuka?* = Do you have any cilantro?
*Chotto matte kudasai.* = Wait a minute, please.
*Arigato gozaimasu.* = Thank you.

*Itadakimasu* is a phrase said before one eats. It loosely translates to "thank you for this food."

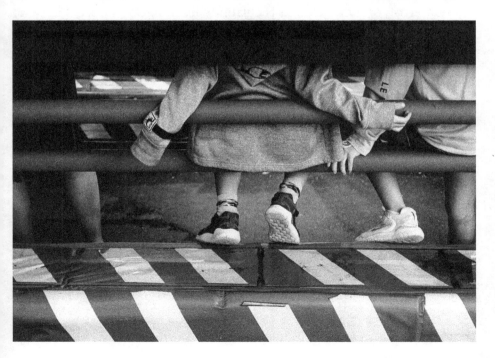

# Joseph Bonney

Joseph Apagya Bonney (artist name: Joe Bones *(ジョボンズ))* is from Austin, Texas but currently lives in Osaka, Japan. He is an artist, writer, hip-hop artist, and model, and is currently learning Japanese. "I hope to bring some level of creativity to the world that people like or dislike, or even have other feelings for."

四要素ブラックパワー

ジョボーンズ

四
要
素

コメット

ツョ
ボンズ

# Tina Meeks

Tina Meeks is a Bay Area born poet and event coordinator. In 2018, she self-published her first book, Adolescence. She has also published work with Rigorous Mag, NNOKO African Literature, Other Worldly Women Press, In the Hands of Community Chapbook, and INDIGO Online Magazine and plans to keep sharing. When she's not writing, Tina's juggling, experimental cocktail making, adventuring, and doing film projects that pique interest and strike her fancies.

## Leaves

Leaving a bitter taste in my mouth,
we part ways into the world,
somehow synchronized.
This place that leaves leaves to blow in the wind.
Drifting nomadically,
the way I need to be.
Habitually eidetic with every motion
and every word.
The more distance between our hands
makes it hard to feel good, alone.
The temptation to press into you
lingers.
The masses around can fluctuate and move,
and the opportunity to touch,
please remain true.
As true as outer space.
My mind has elevated out of this world
to gather sanity.
Serenity in the clouds
and sanctuary in the puddles.

## Samuel P.

Dust rises from what was not a fall,
but more of a popularity contest.
When the sound of running water is prevalent,
this place comes to mind.

The only drama here is what inches of water
can bounce off the rocks first,
even though everyone gets a turn.
There's something about the redwoods
that manipulates the world
into something gorgeous again.

The trees are as tall as gods,
they'll make you believe anything

because they've achieved such heights
and go to such lengths
to maintain the perfect ecosystem
for all the entities around.

Thinking of Samuel P. is one
of the easiest ways to
calm myself down, because
even though that place
burned partially in wildfires,
it never lost its resilience.

We are mere beings that take
for our selfish selves
and here is a place
that contributes unspeakable amounts
that have hardly been thanked for.

Samuel P. ascends over its own hills,
through trails beyond the sparks
of campfires.

What ever salmon have the audacity
and desire to flee downstream during high tide,
I hope they know that they are
part of something sacred.

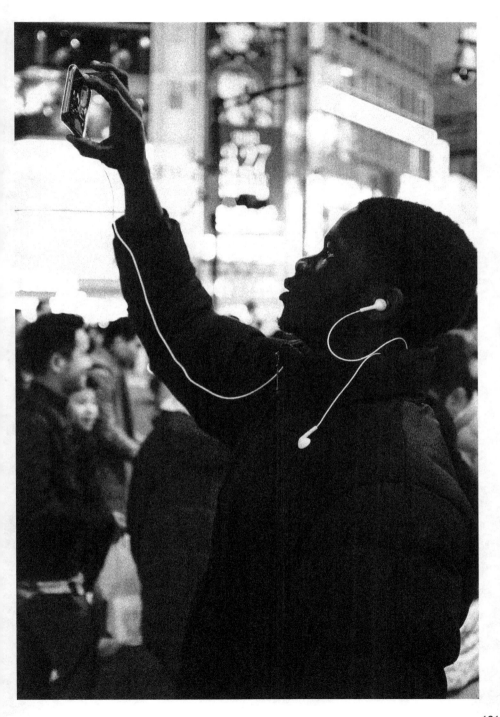

# Shiela Denise Scott

Shiela Denise Scott, a creative with a focus on poetry and photography, graduated from Full Sail University with a BFA in Creative Writing for Entertainment and from Antonelli College with an AAS in Digital Photography. Her published works include Multitudes of Array, Elders Are Cool, Blended Survival, Saddest Thing, Constellation of Stars, Bar Belles, Crumbled Promises, and other stories and poems. She turned her hobbies into a career and fell in love.

## The Darkest Cloud

Hovering above me,
the enemy twirls,
around in the sky,
without warning,
alarmed at the shapes,
that change,
each time it,
swirls high,
until,
it reaches the Earth,
and grabs me,
Shaken by the nature,
I try to remain still,
hold onto the wheel,
and direction,
only to lie,
in the midst, odd times,
losing all touch,
with connections,
No longer I live,
or can I forgive,
Oh, the damage it left behind,
when high up above,
touched what was low,
then left other lives,
but took mine.

# Tabitha Anesie Mitchell

Tabitha Anesie is a theatrically trained actress, creative writer, and poet. Her most recent project, A Word From the People: A series of letters in response to (anti) Blackness in a racially conscious society, was released as a collection of letters, poems, and calls to account in June of 2020. Prior to relocating to Tokyo, Japan, Tabitha worked as an actress in Los Angeles, CA, where she completed the first year of the Meisner Technique at The Sanford Meisner Center in Burbank, CA. Tabitha received her Bachelor's degree in Theatre Arts at Loyola Marymount University in 2017, where she trained in acting for the stage, film, Shakespeare, and voice development. Her playwriting credits include The Journey Through, an autobiographical solo piece on the actors' journey. She is also known for her work as Lisa in the film January 14th, Nairobi in Raft of The Medusa, Dr. Livingston in Agnes of God, and Sara in Rhyme, Reason, and Circumstance.

## Baptized, Sinless

I suppose now you expect me to forgive you.
For me to lower my head and cover my eyes as you resume position.
I suppose you want to hear me lie.
I'll lick my lips to make it sweet, more believable.
It's alright, I'll sing to you if you so desire. If it'll make the guilt fade.
You feel guilty, don't you? Don't you?
Never mind, no need to answer. Be still! I'll sing to you some more.
A lavish tune. One that'll take all the regret away.
I'll sing louder to drown out the noise.
My throat's burning. Louder!
I'm fighting back tears. Louder!
Blood is beginning to fill my lungs. Louder!
I cock my head back so the blood doesn't overflow. Louder!
I begin to choke, but you seem more at ease. So, I lower my head.
All that I'd been holding back begins to rush out of me.
I hope it baptizes you so that you might consider yourself forgiven.
Covered. Free of Guilt. Sinless.

## Voiceless

Well I am angry.
livid!

                                                    I searched for you.
                            Screamed your name until my voice cracked.

Until I was voiceless.

                                                You never answered.

# Michael Johnson

Michael Johnson is a reader, writer, listener, speaker, teacher, and student living in Misawa, Japan. He started writing after listening to his brother's Run-DMC album, desiring to use words in the same powerful way they did. As a young man, he dabbled in both secular and gospel rap music for several years before discovering that the written word did not need music to present powerful messages. As an adult, Michael has discovered the power of grace in his roles as husband and educator, and especially as a father of seven children. Grace is the power to live in the light, to think independently and yet utilize the accumulated knowledge and wisdom of the fathers and mothers who came before us. Grace is forgiveness and discipline, creativity and imitation. Grace is the point from which all that he writes originates, and he humbly uses that grace to positively impact others through his written and spoken words.

## Two-Fifths

What happened to the rest of me
What was done during the time
That I was stripped of my evidence
And beaten out of my mind
There was no resurrection
Though they crucified my soul
Feet firmly planted on the block
Naked, scared and cold
Tell me that I'm still a man
Don't let them take it away
We only hope to till our land
Our fathers were never slaves
But they say I'm not a man
Not complete and whole
Three-fifths isn't near enough
George Mason told me so
So why am I still for sale
Why don't I own my life
And if two-fifths is all it takes
Two fists will make it right

## Hush

be quiet...the wind is
speaking to you...had
I ears that could hear
her voice...I'd blush
at the things she tells
you

# Michelle Keane

Jamaican animator living in Japan, Michelle Keane is using her work to address mental health, racism and black negative stereotypes in an industry where being black and female is an anomaly. She graduated in 2019 from Kyoto University of Art, where she completed a master's degree in animation, and is now poised to make waves having already produced two stop motion animated films, one of which has aired in several film festivals, as well as a couple of animated shorts for Cartoon Network's Adult Swim.

# Ravelle-Sadé Fairman

Ravelle-Sadé Fairman, a.k.a A Poetic Perception, is a self-proclaimed accidental Poet, Spoken Word Artist and Workshop Facilitator. She started writing three years ago and after realizing the impact of her honesty, Ravelle-Sadé has been actively overcoming her own battle with mental health to share her insight through her Poetic Perception. Ravelle-Sadé is passionate about trying to address societies taboos with the hope that it may help others to see that they aren't alone. Since then, she has shared her poetry at numerous schools, universities, libraries, festivals, Youth Parliament, the BBC and organizations such as the NHS.

**Africa**

A continent, not a country.

They called themselves tree surgeons
Claimed that our roots were infected
So, they offered their expertise
Just not for free…

They used the guise of being more civilized
To justify chopping down our tree
Then used the same wood to create books
that rewrote our history into his story
My ascendants' memory, a mystery
Even when I strive to research about their lives
My ancestors' existence feels;
Too unearthed to ground
Roots too fragmented
to trace the sound back
to familiar soil

Although,
I parade the coils of my forebears
I feel their spirits embody rhythms
Which are familiar to my system
Yet your tongue speaks in distance
Mine in colonization…

The resulting hole from our felled tree
carves out Jamaica
I know that this is where I belong
But
Where do I really come from?

Yours sincerely,
A child of the Diaspora.

Your tongue speaks of resistance
Rolls and clicks, too complex to mimic –
I am in awe of your resilience
Of your ability to maintain
what they try to take away
Deeming it savage and ungodly
Making a mockery of your traditions

Yet your vibrant colours make statements
Identification with no hesitation
that you. are. here.
Proud of your heritage
Worthy of the heads that turn
when they learn of your presence
Culture so rich that it drips from your essence
Teaching me an unapologetic lesson
of belonging

You feel like home.
So close, yet so far...

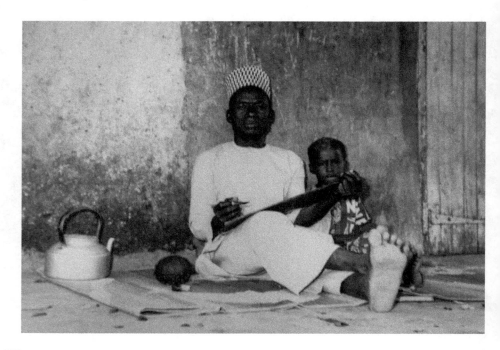

# Biankah Bailey

Biankah Bailey is a writer and educator from Kingston, Jamaica. She has been teaching English in Japan for over a decade and currently resides in Saitama Prefecture with her husband and cat. Some of her written work has been published in Musings, an anthology series by Writers' Bloc, Tokyo as well as in ToPoJo Volume I, published by Tokyo Poetry Journal.

# Welcome

She sank her heels into the wet sand, willing the purple ocean to bring the tide to her ankles so that she could feel like she was finally there.

They had promised us a better life, she thought. Might as well trust and believe.

Trust and believe. Those words were on so many of the leaflets they distributed when they first landed on Earth. She once half-jokingly told her mother that the Ixians' attempts at winning hearts and minds felt like being proselytized to by church people.

"Oh, don't be so cynical," her mother scolded, "This could be good for all of us. It's not like there's much left for us here." She gestured at the thick smog and mountains of trash that made up the landscape of the last Earth city they lived in.

She spent much time wondering why they had fled their slightly less polluted planet to go to Earth. What were they to gain by helping us, was what she often wondered. She walked through the old streets of their great cities, looking for concrete answers to her many questions.

She walked and searched for what felt like ages, only to see the occasional flyer, leaflet, message carved into stone, and graffiti on a few walls in a multitude of different languages:

WE ARE HERE.

"Brynn, you look like you're miles away."

Brynn was so startled by the sound of her name that she almost lost her balance. She turned around to see her Ixian language, history, and culture instructor decked out in iridescent blue robes and an aquamarine tiara.

"Miles away. That's the expression in your language, correct?" They flashed a disarming grin.

"Yes, that's correct," Brynn smirked. "You know, at this rate, I'm probably

teaching you more of my language than you are teaching me yours."

They threw back their head and howled in amusement. "You're probably right. Probably right indeed. Come, why don't I help you pick out an outfit for the gala? You may even choose from one of my own robes if you wish. I would be happy to have one altered to suit your height."

"Oh no, I couldn't."

"Please, Brynn. I insist."

"You know, it still feels strange not knowing what to call you especially after knowing each other for two Earth months."

"Perhaps one day, your mind will be able to project the image that is my designation."

"When do you think that will be?"

"When it's time."

\*\*\*\*\*

After taking up her instructor on their offer, Brynn accompanied them to the Great Central Hall, which was the center of all cultural and civic life in the city. It still bothered her that she had no system for naming people and places. Proper names in their language were designated unique symbols that were projected telepathically. This process of naming and using names seemed so intimate to her. She longed to feel a stronger connection to these people who had been so kind and welcoming to her and to this place she now called home.

She looked up at her teacher, who stood a good three feet taller than she. "You never did tell me why the planet had a name that was communicated verbally. Is it for the benefit of other species?"

They closed their eyes and took a deep breath. "Well, you have a very curious mind, so you were bound to find this out sooner or later. Yes, your

assumption is partly correct. We kept the verbal name for the benefit of other species in the galaxy. There was a point in our history when we did not communicate verbally at all."

"Your people used to be totally telepathic?"

"Yes." They sat on a stone stool and motioned to the one across from them. "We were once a race that communicated only by telepathy, but that was taken from us, along with the true name of our planet." They looked at Brynn, their black eyes more intense than she had ever seen before, and said, "Your race suffered something similar at the hands of another Earth race, I believe."

"You're talking about slavery. Yes, that was outlawed on our planet centuries ago."

"Similarly, our bondage ended centuries ago, but we are still bonded to that past through language." They beckoned to one of the metallic hieroglyphs on the wall, and the symbol projected itself down onto the floor between. It showed moving images as Brynn's instructor narrated. At that point, a small crowd of humans and Ixians had started to gather around them.

"The Xerctians were once a race of energy beings, unable to take corporeal form except by occupying the bodies of others. This is how they expanded their empire—they would take just a large enough contingent onto a planet, invade the bodies of the planet's inhabitants, and force those inhabitants to mine all the planet's resources until it became uninhabitable. They would then leave the inhabitants' sick, overworked bodies on their sick, overworked planet to die, and then move on to the next planet."

A figure in the crowd started to shift uncomfortably. Brynn realized that she had seen him before—he was an official from another planet's embassy but she couldn't remember which.

"The Xerctians harbored an especially intense hatred of telepathic races, often using brutal technology to rewire our brains in order to force us to communicate verbally. Telepaths could communicate ideas without their

knowledge, so telepaths were not to be trusted. They took every measure possible to break us, but we were the first in this galaxy to rebel."

The crowd around them had grown larger, and the emissary Brynn had spotted was fidgeting even more.

"Soon, colony after colony started to rebel, but something else started to happen—after centuries of occupying the bodies of others, the Xerctians slowly started to lose their ability to exist non-corporeally. They evolved into beings with physical bodies."

A human man who was near the front of the crowd asked, "What do they look like?" The question sent a murmur throughout the crowd.

"Their evolution was so unpredictable because of their occupation of so many races, that the last time there was a recorded image of any of them, they resembled at least five different species. Now, no one really knows what they look like."

Murmurs intensified, punctuated by a few very clear gasps of shock among the humans.

"There have also been reports that they had completely retreated to their own planet," one Ixian scholar offered.

"Perhaps," one member of the city council added, "but still, we must remain vigilant."

\*\*\*\*\*

The gala was the most splendid event any of the humans had ever seen. Signs miles tall flashed the words "Welcome to Ixios" in all the Earth languages the Ixians had managed to learn in such a short period of time. There was more food than the entire city could have eaten that night, and the mood was festive and hopeful. Brynn was having the time of her life, eating, dancing, and laughing with new friends. Everyone stayed until it was absolutely time to close the hall. No one wanted the night to end. That was when they saw it. That was when Brynn saw him—the nervous emissary from before. He had a tablet in his hands, entered a sequence of

symbols, and then something flew off the top of the hall's main tower and exploded in the sky, displaying a series of blinking signals.

Brynn walked over to her instructor, who, like everyone else, was looking at the symbols, mouth agape.

"What do they say? The symbols look Ixian, but I can only make out two of them."

They squinted. "Looks like ancient Ixian. I believe it says 'We are here.'"

"That is what it says, but the language is Herctian," said the city council chief, stepping forward.

"Is it a message? What does it mean?" a human woman asked nervously.

"It could be a warning," the council chief replied, "or it could be a beacon to ships lying in wait out there."

Brynn's stomach sank. She had spent all this time wondering about the Ixians' motives, the reason for all their kindness to humans and other species in the galaxy, not once thinking that they were trying to build an alliance in the event of an attack. Why all the secrecy, she thought bitterly, why didn't they just tell us?

Suddenly, just as she started to feel angry at the Ixians, she saw a soft glow in front of her. It grew and grew into an intricate arrangement of lines and she instantly knew what she was seeing. She looked over at her instructor, then looked at the crowd and saw humans and Ixians silently connecting in a way she had never seen before. The Ixians, vulnerable in the face of their fear, were sharing the most intimate part of themselves with the humans. She reached over and took her instructor's hand.

"Together then?"

Brynn nodded, uncertain of what the future held.

"Together."

# Marvist

Marvin Thompson (Mavartist) is an art teacher and a mixed realistic artist. Over his decades of diverse practice, he has generally used art as an instrument for didactic intentions. His personal statement includes, "I am an art teacher and I am an artist. My artworks are my lessons and showing my art to the larger public expands my classroom…". He generally uses painting, drawing, and sometimes sculpting materials to explore social, political, philosophical, and scientific issues.

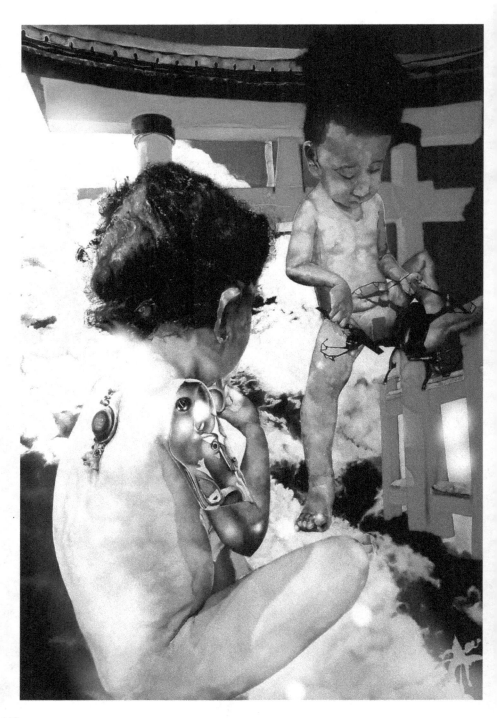

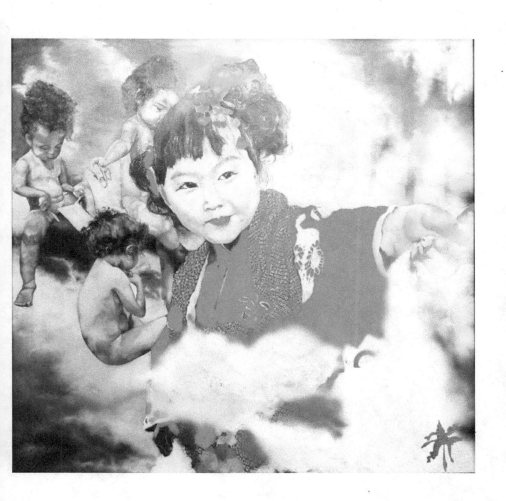

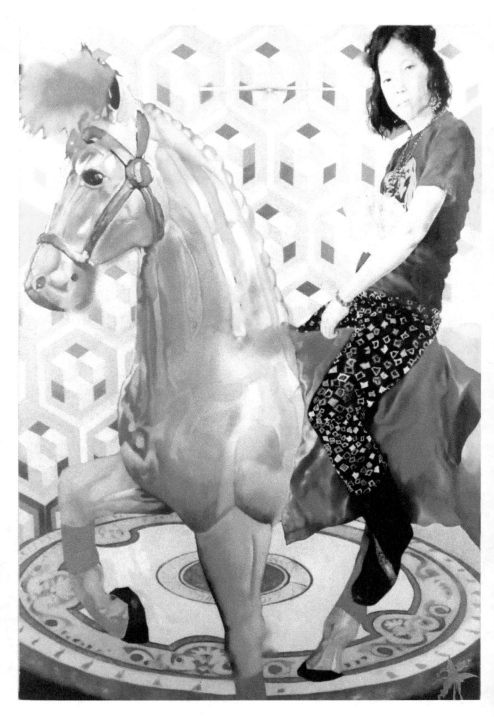

# Notes

## Acknowledgments

We would like to acknowledge Jeffrey Johnson, who first proposed creating this volume. Thank you very much for your incredible support. We would also like to acknowledge everyone who worked tirelessly to keep poetry alive and kicking in Tokyo. Writing groups like Writers' Bloc, Tokyo and Drunk Poets have helped nurture talent in our metropolis for years. We are incredibly grateful for your dedication.

We would also like to give a special thanks to Shunsuke Asakawa at Haretara Sora Ni Mame Maite in Daikanyama for his wonderful support. Shunsuke is a true champion of music, art, and poetry.

Finally, we'd like to give a shout-out to the late great Mr. Edgar Henry. You are gone, brother, but you are most certainly not forgotten.

A very special thank you goes out to all of the global contributors who answered our call for submissions.

## Additional Images

Additional images were added but not labeled. The respective creators are as follows:

> *Michael Harris*: page 19, 113, 121
> *Herbert Kendrick*: page 49, 133
> *Marcellus Nealy*: pages 37, 43, 48, 71, 93, 102, 103, 106, 107
> *Augustus Browning II*: page 132

## More information

For more information on future volumes, how to submit your work, or how to purchase a book please visit the Tokyo Poetry Journal website. https://www.topojo.com

**For information on future events and calls for submission, sign up to the UMOJA mailing list here:**
https://forms.gle/kyU8nnt3yDKH1m8t9

CPSIA information can be obtained
at www.ICGtesting.com
Printed in the USA
BVHW061518170322
631771BV00011B/825